A–Z

OF

CARLISLE

PLACES - PEOPLE - HISTORY

Andrew Graham Stables

AMBERLEY

First published 2019

Amberley Publishing
The Hill, Stroud, Gloucestershire, GL5 4EP
www.amberley-books.com

Copyright © Andrew Graham Stables, 2019

The right of Andrew Graham Stables to be
identified as the Author of this work has been
asserted in accordance with the Copyrights,
Designs and Patents Act 1988.

ISBN 978 1 4456 8411 6 (print)
ISBN 978 1 4456 8412 3 (ebook)

British Library Cataloguing in Publication Data.
A catalogue record for this book is available
from the British Library.

Typesetting by Aura Technology and Software
Services, India. Printed in Great Britain.

Contents

Introduction

This book is not the definitive A–Z of the city of Carlisle, nor is it a series of road maps to assist with your navigation of this historic border town, but I hope to bring you a selection of historical events, people and places who have helped to create the character of this fascinating place. It will include stories from the past, organised alphabetically and chosen because they either piqued my interest or I felt were essential to the story of the city. Some of the history will be well known and some will be a little less familiar, but all aspects are a crucial part of the story. Now considered a border town but once deep inside the Strathclyde and Galloway region ruled by a powerful king, the kingdom stretched from the River Clyde down to south Cumbria. The history of Carlisle is dominated by the relationship between Scotland and England, and the conflict endured by both sides over the years. Carlisle is on the natural route from west Scotland to the west of England and has at times suffered at the hands of both sides. The city has also endured the ravages of starvation, plague and numerous catastrophic fires, but has always responded with courage, ingenuity and stoicism. A city built on history, always torn between the crowns of England and Scotland, but willing to modernise and move with the times to continually reinvent itself.

The format and size of the book make it easy to carry around with you while exploring the city and visiting some of the buildings, especially the Tullie Museum, castle and cathedral. I will of course be including many of the events associated with these buildings and will be looking at some of the most influential people involved in the story of this city. At times I may also look at the more unusual aspects of history and examine the lesser-known events that have shaped the region. On your tours, make sure you partake in the food and drink on offer at one of the many hostelries who ply their trade in the city.

Carlisle lies 20 miles north of the Lake District.

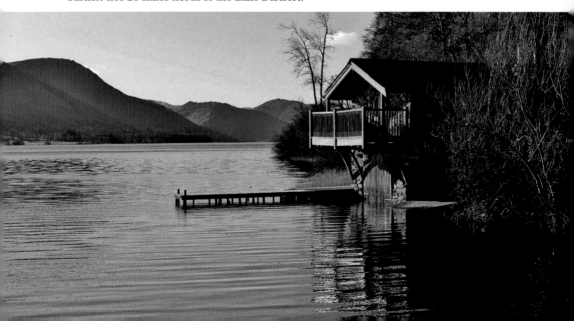

This book will not give a complete picture of Carlisle's enthralling history, but that was never the intention. What I have included are some historical maps and interesting locations, or I may suggest other nearby attractions of interest, but most of all, I hope that you will find the book interesting and maybe, just maybe, an entertaining read.

Defoe visited the city in 1724 and reported that 'the city is strong, but small, the buildings old, but the streets fair ... There is not a great deal of trade here either by land or sea, it being a mere frontier', while in 1759 a merchant from Bristol called it 'a small deserted dirty, poorly built and poorly inhabited'.

However, this from an 1847 *Gazetteer*:

The approaches to the city on all sides are strikingly picturesque, and its vicinity to a branch of the sea, as well as its due distance from the surrounding mountains, render the air salubrious and temperate.

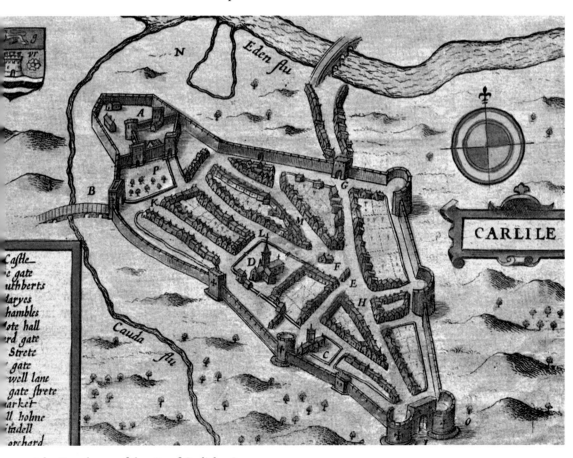

John Speed map of the city of Carlisle 1611.

A

Agricola, Gnaeus Julius

Does the city of Carlisle start with this man?

Well maybe not, but he certainly had a significant influence and in all likelihood he was responsible for a major part of the works at the fort, which was all part of his mission to establish a powerful base from which to launch an attack into what is

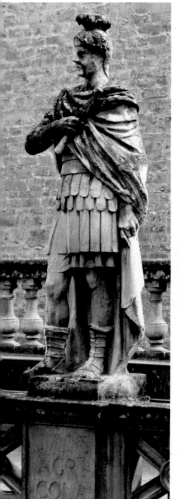

Above: Plumpton, just to the side of the A6 (old Roman Road).

Left: A statue of Agricola erected in 1897 at Bath.

Another view of Plumpton.

now Scotland. Some recovered timbers date the fort to AD 72–73 and Agricola was not made governor of Britain until AD 78, so the first timber fort may have been started as part of Quintus Petillius Cerialis' campaign against the Brigantes tribe who rebelled under their leader Venutius. The Romans moved out from York to take on the Brigantes and crossed the Pennines from Catterick following the route of the modern-day A66 road. The temporary marching camps at Rey Cross, Crackenthorpe and Plumpton Head (known as Old Penrith) near Penrith have all been attributed to the campaigns of this governor.

Agricola began his career as a military tribune in Britain and may have been involved in the defeat of Boudicca in AD 61. It was during Agricola's support of Vespasian to become emperor in the Roman civil war of AD 69 that Venutius took advantage of the disruption to rebel against the Roman rule. His reward for his support of Vespasian ensured his rise to command of a legion in Britain under Quintus Petillius Cerialis, who was the governor between AD 71 and AD 74 and Agricola was later appointed as governor of Aquitania (south-east France). Continued resistance in Britain led to his appointment as governor of Britain and an immediate campaign in north Wales including the clearing of the druids in Anglesey.

Using Chester and York as strongpoints and establishing forward bases at Carlisle and Corbridge, over the next few years he moved north into Scotland; he even

ventured beyond the River Forth-Clyde line and even confronted tribes beyond the Tay. Renowned for his fort building and ensuring the security of his supply line north, it is inconceivable that he did not improve the fort at Carlisle in his pursuit of his advance. By AD 84 he was successful in crushing the Caledonians in a battle at Mons Graupius but at the end of the year his feats warranted the attentions of the emperor Domitian and he ordered him back to Rome. Once in Rome he was 'granted triumphal insignia though not actually afforded a triumph' – these honours were reserved for members of the imperial family.

Gnaeus Julius Agricola died on his family estate on the Mediterranean coast at Provence in southern France on 23 August AD 93 at the age of fifty-three. He was forced to spend the last eight years in a form of imposed retirement, which seems scant reward for such a successful military career.

The A6 into Carlisle from the south is the fourth longest road in England and is the route of the old Roman road.

B

Botchergate

Botchergate sits just to the south of the Citadel, which is on the southern approach to Carlisle, on the route of the old Roman road, sometimes called London Road and now the designated the A6. Botchergate was previously called 'Botchardgate', named from a southern gate called 'Porta Botchardi', which may have been named after a native of Flanders called Botchard. The area was originally outside the city walls, but over the years grew to serve travellers who were locked out of the city after dark under the orders of Elizabeth I. The street still seems to have this feel, as it contains numerous bars, hotels and eateries.

From the time of King John there was a leper hospital on the site, somewhere just south of South Street and around St Nicholas Street. St Nicholas Hospital was

Botchergate from an old postcard.

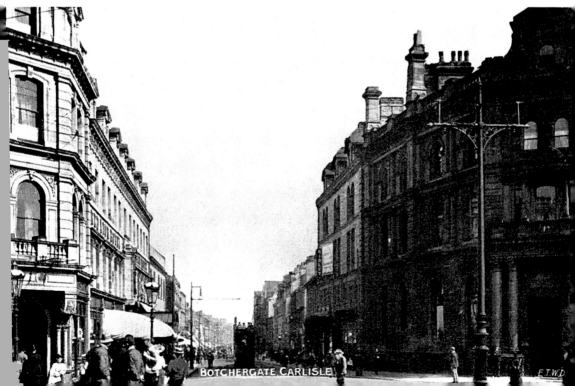

BOTCHERGATE CARLISLE

sacked at various times including in 1296 and 1338, and in 1393 a clerical commission reported neglect, corruption and overstaffing. There is now no trace of the buildings and nothing remains but the name of the district of St Nicholas in Botchergate. A parliamentary survey of 1650 reveals that the hospital was completely destroyed during the siege of Carlisle in 1645. Burials have been found in the area beside the road on the south and east where the churchyard is said to have been. The area where the hospital and the graveyard stood is now covered with buildings and streets.

Most of the expansion on Botchergate occurred during the eighteenth and nineteenth centuries – maps from the era show a strip lining the road for only a few metres but steadily expands once the railway comes to town in the mid-1800s. As you would expect with railway development, Botchergate built streets of working-class housing, interspersed with the industry associated with the rail or taking benefit of the transport link. The street is now a mix of residential, commercial and retail, helped by the proximity to Carlisle Citadel Station and the growing tourist trade attracted to this historic city.

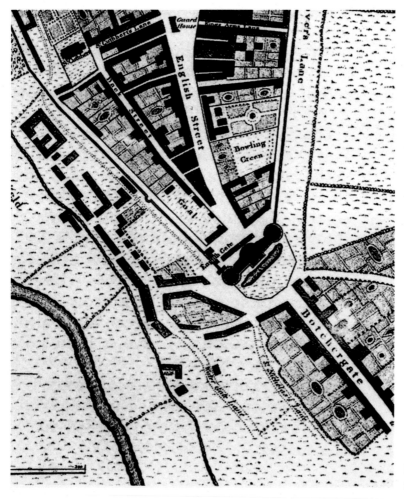

Botchergate map from 1750.

C

Carlisle Castle

As with a great many Norman castles in the north, the castle at Carlisle is built over part of the Roman one and this is probably for two reasons. Firstly, the position of the Roman fort was originally picked for strategic reasons, with the site protected by the rivers Eden and Caldew and the Normans also realised this. Secondly, it would make sense to reuse some of the building materials and ditches from the Roman fort to build and protect the new castle. When William II succeeded his father 'the Conqueror' in 1087, Cumbria was part of the kingdom of Galloway and Strathclyde under Scottish influence. Taking advantage of a Norman feud between William and his brother, Robert Curthose, the King of Scotland, Malcolm III, had invaded northern England, until William, at the head of an English army, pushed Malcolm back in 1091, forcing Malcolm to pay homage. The following year William invaded Cumbria to take out Malcolm III's retainer, a powerful Anglo-Saxon noble called Dolfin. To take control of the region William instigated the building of a castle at Carlisle and imported English settlers to entrench English power in the north. The Anglo-Saxon Chronicle stated:

> In this year king William with a great army went north to Carlisle and restored the town and built the castle; and drove out Dolfin, who ruled the land there before. And he garrisoned the castle with his vassals; and thereafter came south hither and sent thither a great multitude of [churlish] folk with women and cattle, there to dwell and till the land.

It is thought the first castle may have been a simple ringwork using the natural slope to the north and a deep ditch cut as a defence to the south. It may have also reused the remaining Roman defences to bolster the new castle. Henry I visited Carlisle in 1122 and ordered that it be 'fortified with a castle and towers' and it is thought this order began the building of the keep. The castle works were still in progress in 1130 and after Henry I's death in 1135, Carlisle was retaken by David I, King of Scotland, who is said to have built 'a very strong keep' there. It may be that David I completed the keep, but this for the purposes of defending against any English counter-attack. David died in Carlisle on 24 May 1153, aged around seventy-three, before being buried

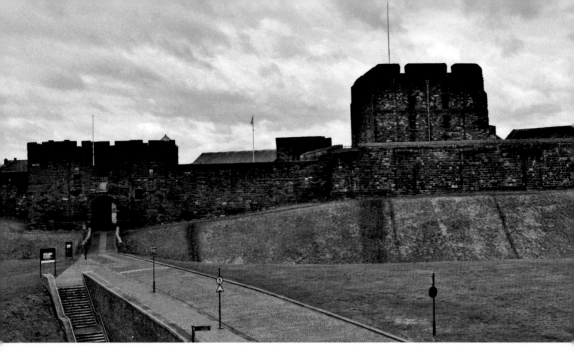

Carlisle Castle entrance.

in Dunfermline Abbey. His grandson Malcolm IV took the crown but in 1157 Henry II summoned Malcolm to meet him at Chester. He signed the Treaty of Chester, where Malcolm relinquished his claims to Northumbria, Cumberland and Westmorland, including Carlisle.

Henry II visited Carlisle in 1186 and ordered further alterations to the castle complex, including buildings of the inner ward, and under King John in the early thirteenth century it is believed an outer curtain wall was added. Edward I's campaigns against the Scots in the late thirteenth century led to further modifications and a residential tower being built to improve the comfort of the accommodation.

Following the victory over the English at the Battle of Bannockburn Robert the Bruce besieged the castle but failed due to an interesting character called Andrew Harclay (see the letter H), who was rewarded by Edward II and made Earl of Carlisle in 1322. There was another siege in 1461 during the Wars of the Roses when a combined army of Lancastrians and Scots took the castle from the Yorkists, one which included the early use of gunpowder weapons. It would be the onset of gunpowder weaponry that would make traditional castles obsolete over the following years, but it was not until 1541, under the direction Henry VIII, that a Moravian engineer called Stephan von Haschenperg was employed to make significant changes to the defences. The keep was lowered with an artillery platform added to the roof, the inner ward walls were strengthened and the half-moon battery was erected. The battery was originally higher so the soldiers could shoot out over the outer ward, but it was levelled in the nineteenth century.

Carlisle has always played a part in the border disputes between England and Scotland or rival dynasties but between the fifteenth and sixteenth centuries rivalries between clans and family groups across the whole border resulted in a period of

lawlessness and blood feuds. The borderlands from lowland Scotland, Westmorland, Cumberland, Durham and Northumberland was a combat zone where armed bands of men known as 'reivers' regularly robbed and pillaged their neighbours. Famous reiver families like the Armstrongs, Robsons and Charltons had little allegiance to the English or Scottish crowns, but had a loyalty to a family or clan group. They were ruthless in their raids to claim herds of cattle or flocks of sheep and cross-border attacks could often lead to destruction or murder. As the centre of north-west judiciary, Carlisle Castle was often used to incarcerate reivers, where a famous case involving the notorious William Armstrong of Kinmont ('Kinmont Willie') played out. A large armed group of his family and friends broke into the castle using ladders. They set him free on 13 April 1596. When in 1603 James VI of Scotland became King James I of England, there was a determined effort made to bring peace to the border and eventually the border reiving came to an end.

The castle was involved in a notorious saga when in May 1567, Mary, Queen of Scots fled from her rebellious subjects to England and was housed for several weeks in the Warden's Tower, later called Queen Mary's Tower. This would be the last time the castle was used as royal residence, albeit a foreign queen and her court. During her stay it was Elizabeth I who supported her cousin at an average cost of £56 a week in food and wine (see the letter Q).

During the Civil War the castle was garrisoned for the king by the Marquis of Montrose and suffered from a series of short sieges by the Scots and Parliamentarians. Later in 1644, Sir Thomas Glenham, who was the commander-in-chief in the north,

Carlisle Castle.

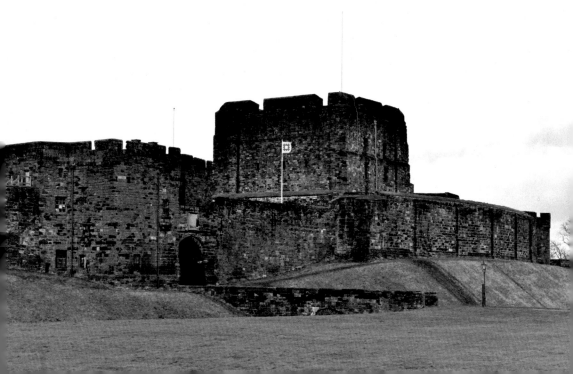

after the capture of Newcastle, took his forces into Carlisle. From October, he was besieged by Major General Sir David Leslie, with a detachment of the Scottish army, but Glemham sought an active defence and would repeatedly raid the besiegers' lines. The siege lasted nearly a year and provisions had been exhausted with the inhabitants said to be eating their horses, dogs and even the rats before they capitulated in June 1645. Leslie granted honourable terms of surrender and allowed the garrison to leave with all the honours of war.

The next threats to security were the Jacobite risings of 1715 and 1745 (see J for Jacobites). The 'fifteen' petered out after the indecisive Battle of Sheriffmuir, but the 'forty-five' was a completely different matter. Prince Charles Edward Stuart (Bonnie Prince Charlie), on his march south, took the city and castle after a short siege but as he headed deeper into the heartland of England, the expected support never materialised and the Scots decided to return north to Scotland. The indecision had given the Duke of Cumberland time to gather an army, who chased the Scots north with a skirmish occurring at Clifton. The Scots left a rearguard of 400 men at Carlisle, with much of the garrison coming from Jacobite recruits from Manchester, but Cumberland's army arrived outside Carlisle

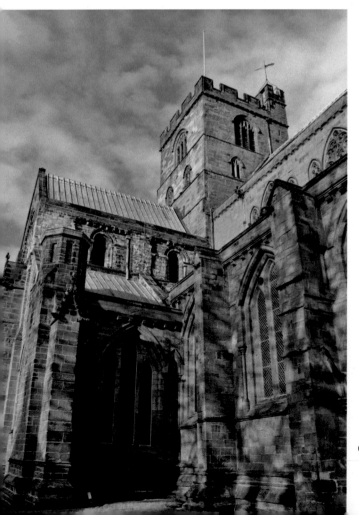

Carlisle Cathedral, St Mary's.

on 22 December, and seven days later the garrison was forced to surrender. Many of the rebels were imprisoned and later thirty-one were executed. Some of the prisoners famously survived by licking the moisture from the walls of the dungeons. The rebellion ended in 1746 when the Duke of Cumberland defeated a Scottish force at Culloden.

The final story of the castle is as a military garrison and an army barracks before eventually becoming an English Heritage site, the centre for county's emergency planning services and Cumbria's Museum of Military Life. A visit to the most frequently besieged place in the British Isles is highly recommended.

Carlisle Cathedral – St Mary's

When I visited the cathedral, I was impressed by its beauty and though the building is not of great size, the incoming natural light combined with the artificial light really brings out the features of this red-sandstone-built house of worship. The cathedral also contains many treasures, carvings and artwork, but a visit to the crypt area reveals delicate silverwork and a chest with a lid that may be of a much earlier date.

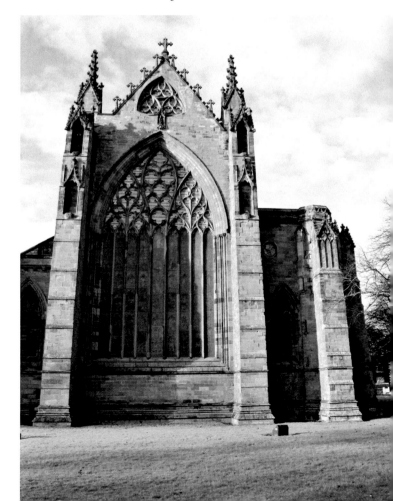

Cathedral's East Window.

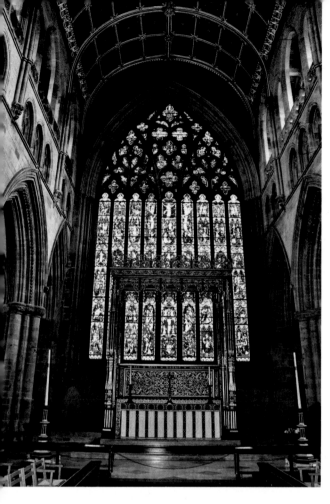

Cathedral's East Window.

The only cathedral in Cumbria was founded in 1122 but is thought to be built on the site of an earlier Anglo-Saxon monastery. Bede tells of St Cuthbert's visit to Carlisle in 685, and he was taken to see some Roman walls and a well. This visit may have instigated the building of a monastery complex, but in 875 it is believed Carlisle was destroyed by the Danes and the town lay desolate until the Norman conquest. The Normans built the priory church that was to become a cathedral in 1133. The cathedral buildings were damaged by fire in 1292 (see the letter F for Fire) and suffered during the English Civil War of the mid-seventeenth century when much of the nave was demolished.

The East Window, at 15 metres by 10 metres (48 × 30 feet), is one the finest examples of fourteenth-century stained-glass windows in the country and beneath the window is a 'piscina', an inset bowl where the priests would wash their hands. There are painted screens in the aisles of the nave that show scenes in the lives of St Augustine, St Anthony, and St Cuthbert. Many places of worship in the country had lost or had their screens destroyed during and after the Reformation. The chancel contains a fourteenth-century, barrel-vaulted ceiling made from thin wooden planks. The ornate, deep-blue paintwork with sun and stars gilding decoration is exquisite. The associated Fratry, built in the 1500s, was the dining hall of the cathedral priory and over the years it has been used as a kitchen, an arsenal, a brewery, a granary and a

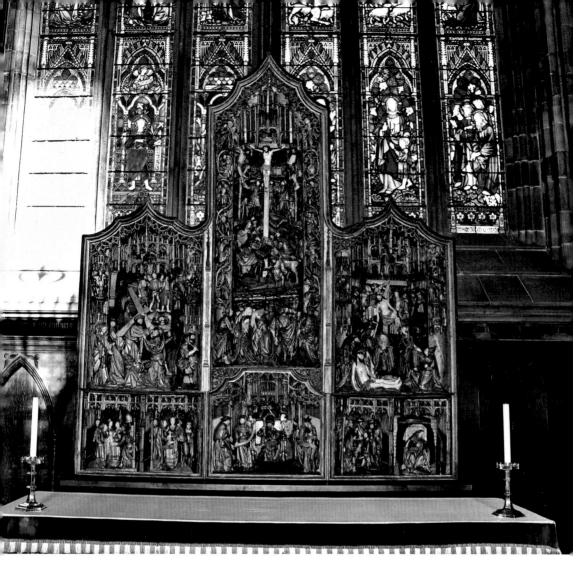

Intricate carved screen in the cathedral.

library. Outside the cathedral, high up on the side of the building close to East Window, is a gargoyle in the image of a policeman and next to him another one wearing glasses (a carving of the sculptor himself).

There is also a legend that the bowels of Richard the Lionheart are interred within in the cathedral.

In 1797, the Romantic novelist and poet Sir Walter Scott was married there and in 1949, the cathedral became a memorial chapel for the Border Regiment.

The abbey complex is a gated area off Castle Street and contains the Fratry, the Reqister Office, the Deanery, and the Prebendaries' houses. The Abbey Street entrance gate was erected in 1528 though it bears the inscription 'Orate pro anima Christopheri Slee, Prioris, qui primus hoc opus fieri incipit. Anno Domini, MDCCVIII' which translates as 'Pray for the life of Christopher Slee, Prior, who first began construction of this building. 1708 AD'.

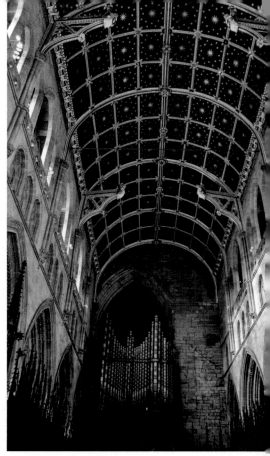

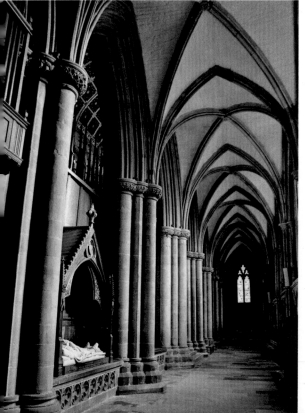

Above left: Abbey Gate.

Above right: Cathedral ceiling.

Left: Cathedral's south aisle.

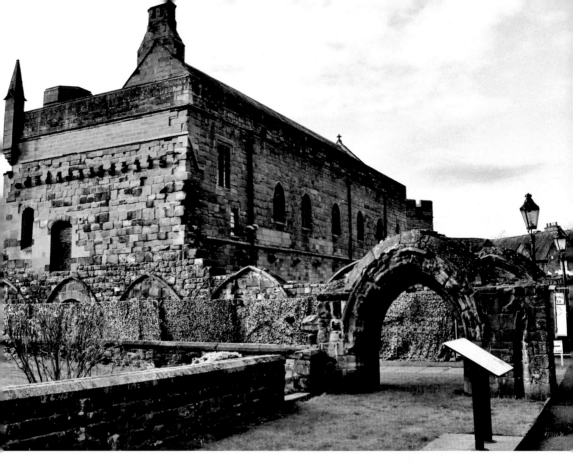

Above: Fratry building.

Right: Cathedral choir.

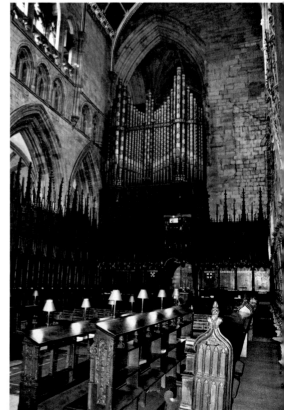

Dixon's Chimney

When Peter Dixon and Sons Ltd built the Shaddon Mill in 1836, at the time it was the largest in the country and the chimney, at 305 feet high, was the tallest in the country and the eighth tallest in the world. This huge seven-storey factory was so large it could

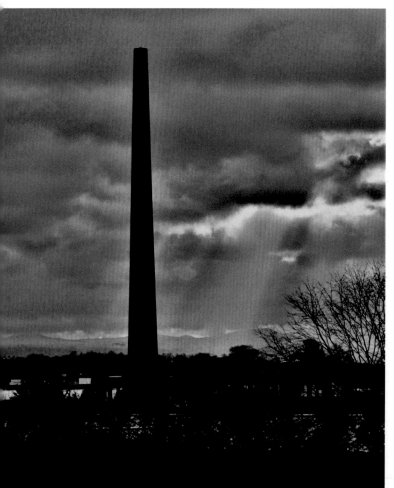

Dixon's chimney in silhouette.

Dixon's chimney at dusk.

not have been powered by water and so steam power was used from the beginning. The chimney, built by Richard Tattersall, has English bond brickwork with flush red-sandstone quoins. It is an octagonal tapering shaft complete with iron tie-bands at the top and bottom. The internal diameter of the chimney measures 17 feet 6 inches with 10-foot walls at the base.

In 1840 Dixon's employed over 3,500 handloom weavers in England, Scotland and Ireland. At their peak Dixon's employed a workforce of 8,000. In 1883 Peter Dixon and Sons Ltd went into liquidation and the mill was taken over by Robert Todd and Sons Ltd, who then used the mill for wool production rather than cotton.

The chimney was damaged by lightning in 1931 and it was necessary to take off the top few feet in 1950 for safety reasons. Now standing at around 290 feet tall but still a popular and familiar landmark in Carlisle, Dixon's chimney is a reminder of its textile history. It was so popular as a local landmark that when in need of repair in 1999, it was restored by Carlisle City Council.

Eden, Caldew and Petteril Rivers

The city is surrounded by waterways in the form of three rivers. To the north is the main river, the Eden, which flows from the Mallerstang in the Pennines above Kirkby Stephen down the Eden valley past Appleby-in-Westmorland, Penrith and towards the Solway Firth. To the east is the Petteril, which meanders its way through the outskirts of the city to join the Eden at Stony Holme near the Memorial Bridge. The Caldew enters the Eden just to the west of the castle after flowing down from the steep slopes of Skiddaw and tracked for much of its length by the Cumbrian Way.

These rivers are a major factor as to why Carlisle is situated where it is. They offered both protection and communication, as well as a good water supply, but of course can mean the area is liable to flooding too. The Roman fort sits on a high sandstone bluff between the Eden and the Caldew, with further protection offered by the Petteril, and between the two a road connection to Chester south and the Stainmore Pass to the east.

River Eden and bridge from an old postcard.

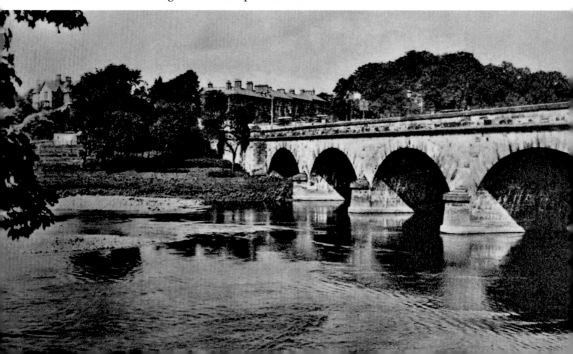

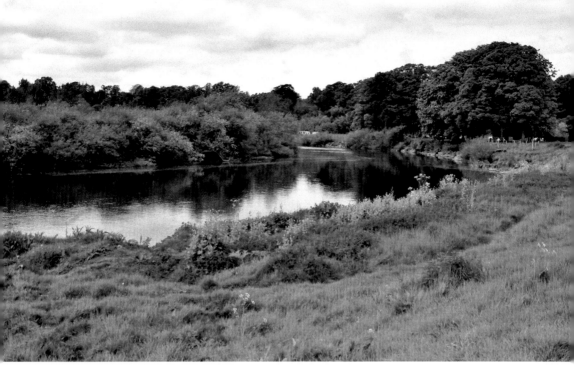

River Eden taken from Rickerby Park.

In the mid-1700s the rivers played a part in the rise of industry, buoyed on by the improvement in roads due to the 'turnpike' system, the wool and cloth industries began to expand. Ample supplies of water for power and the cloth-making process made Carlisle an excellent place for the growth of the cloth industry. The soft waters of the Caldew were especially suitable for bleaching. Cloth was exposed to the sun and steeped in alkaline solutions and the fields around Carlisle would be used for laying out the cloth. These were called 'printfields' and were used up until the early 1800s until made obsolete by the invention of bleaching powder.

With the increase in industry and the roads inadequate for bulk movement of materials, plans were put in place for a canal system to ensure expansion was possible. Various plans were submitted from 1807 by some of the great canal engineers of the time, but with no agreement as to the best scheme, the decision was deferred for ten years. In 1818, the route was agreed from Fisher's Cross near Bowness (renamed Port Carlisle) to Carlisle. Work started on the canal in 1819, with the canal basin close to where Carrs biscuit factory is. The canal opened in 1823 and was 11.75 miles long, with eight locks to accommodate the reasonable 70-foot rise from the sea. The canal was capable of taking coastal craft of less than 100 tons and as well as goods, a passenger trade began to grow too.

The rise of the railways from the mid-1800s began to take over passenger and haulage and in 1853, thirty years after first opening, the Carlisle Canal was closed. In 1854 a railway opened using the canal bed for its route from Carlisle to Port Carlisle, but as the port declined so did the need for a rail link and in 1932 the railway branch line to Port Carlisle was closed.

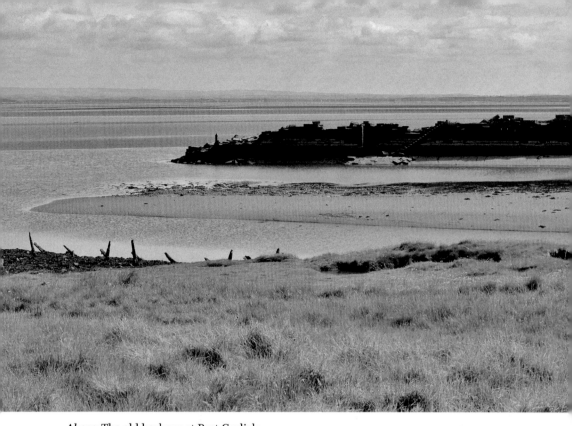

Above: The old harbour at Port Carlisle.

Below: Canal exit at Port Carlisle.

Above: The canal is filled in and overgrown today.

Below: The sign erected in 2015 by Roger in Port Carlisle.

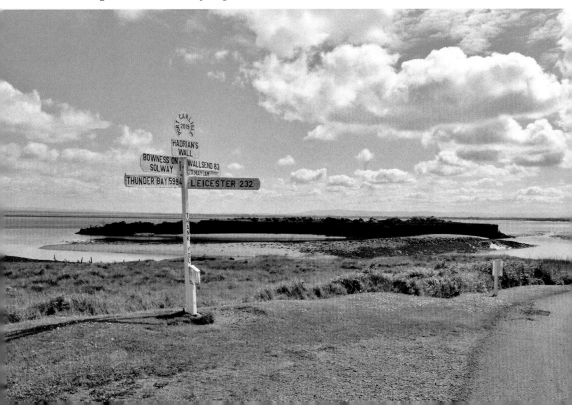

At Port Carlisle in May 2015, Roger, a local resident, decided he would build a signpost similar to the Land's End to John o' Groats sign. Roger is usually on hand to chat and provide knowledge about the local area and you can have your photograph taken by the sign as a memento. He also will fill in your home town by using loose letters with his usually accurate assessment of the mileage from that spot.

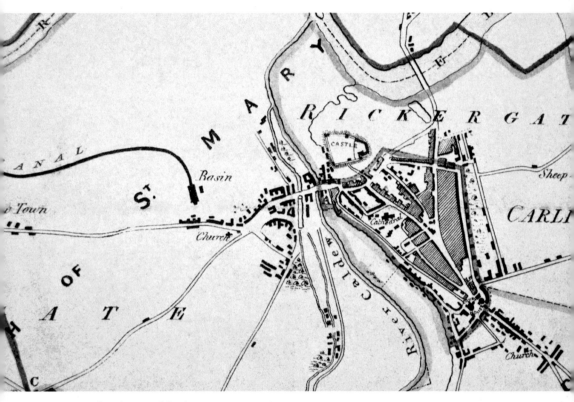

Map showing canal basin.

Fire

In May of 1292, Carlisle was devastated by a fire and a sensationalist account appears in the *Lanercost Chronicle*, a northern English history covering the years 1201 to 1346:

> Satan even caused the son of a certain man to set fire to his father's house outside the town at the west end of the cathedral church, and this, escaping notice at first, soon spread over the whole town, and, what is more, it speedily consumed the neighbouring hamlets to a distance of two miles beyond the walls, and afterwards the streets of the city, with the churches and collegiate buildings, none being able to save any but very few houses. The fire, indeed, was so intense and devouring that it consumed the very stones and burnt flourishing orchards to the ground, destroyed animals of all kinds; and, which was even more deplorable, it burnt very many human beings of different ages and both sexes. I myself saw birds flying about half burnt in their attempt to escape.

In March 1296, following Edward I's involvement in the Scottish succession, the Earl of Buchan attacked Carlisle and though successfully rebuked by the inhabitants, fire once again struck the city. Half of the city was lost again when a Scottish prisoner managed to start a fire in the prison. The medieval city would have consisted of mainly timber-framed buildings with thatched roofs, with the city walls, churches and fortifications being the obvious exceptions. The fire destroyed parts of the cathedral including a wooden ceiling, but very soon after this disaster they began rebuilding the choir, piers and east bay. They also took the opportunity to change the street pattern after the fire with several diverted streets and changes to the main castle entrance.

William Hutchinson also refers to an earlier fire in his histories and it appears a great deal of the town records went up in smoke at the time:

> King Henry Fitz Empress took Carlisle and the county from the Scots, and granted to the city the first liberties I hear of, that they enjoyed after the Conquest. But his charter was burned by a casual fire that happened in the town, which defaced a great part of the same, and all the records of antiquity of that place.

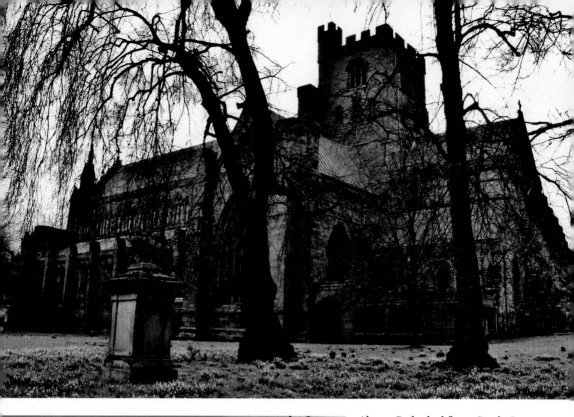

Above: Cathedral from Castle Street.

Left: Old street layouts including
Fisher Street.

Fisher Street.

This was king Henry III who in 1251 granted another charter to replace the first, which had been lost by fire.

Another fire broke out in 1391 when a reported 1,500 tightly packed timber-framed houses were lost – though Towill believes this figure may have been exaggerated to gain more support in the rebuild and indeed the king granted 500 oaks from the Forest of Inglewood to assist the inhabitants.

Further destruction occurred when in 1644 General Lesley and a Scottish army on the side of the Parliamentarians laid siege to the city. Although the city held out for around eight months, the city suffered by fire and cannon as well as starvation before it surrendered.

The layout of the city has been influenced by geography, fortifications and roads, but part of the city topography has been affected by fire and destruction.

G

Guildhall

The Guildhall, close to the marketplace, is a Grade I listed monument and is one of oldest buildings in the city. Originally built as a residence between 1377 and 1399 for Richard de Redness, it became a meeting place for the city trade guilds after Richard left it to the city in his will.

Guildhall.

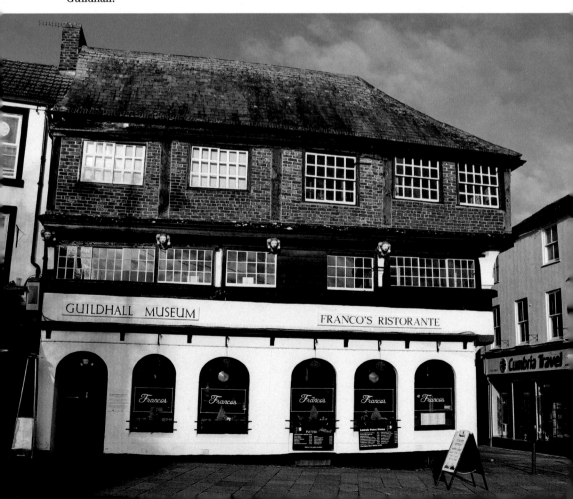

Above: View over Abbey Street.

Right: View down Abbey Street.

The structure of the building shows two different types of construction, although when the timber was dendrochronologically tested it showed it all dated from the time the building was originally constructed. The timber-framed hall with a Cumbrian slate roof has upper floors projecting outwards in the medieval style seen throughout the country. It is also possible the lower floor was open, or on stilts like many other buildings of this style, and used as a selling or market area. It has three storeys and an L-shaped plan, the upper floors are moulded jetties and cornices, the middle floor containing weatherboarding, and the top floor medieval tiles. The windows are varied and include sashes – some horizontally sliding – casements, and one oriel window. In 1978–79, the building underwent extensive renovation, but much of the early timber work survives, as do some wattle and daub internal walls.

Very little documentary evidence of the construction or early structure of the Guildhall survives, and the earliest illustrations or images are from the nineteenth century. The building is now occupied by a private business on the ground floor but the upper floors contain a museum. The entrance and staircase to the museum are relatively modern and it is thought the original entrance was on Fisher Street.

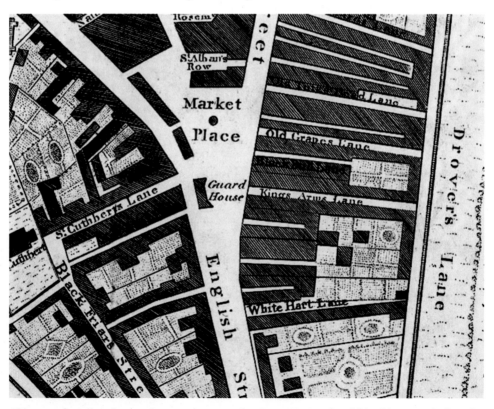

Old map of marketplace and town centre, early 1800s. Notice the old buildings including the Guard House.

Harclay, Andrew – Earl of Carlisle

Andrew Harclay – or Andreu de Harcla, as he was more usually known when he was alive – is an amazing character linked to the story of Carlisle. Born *c.* 1270, into a low-ranking Westmorland knightly family, he rose to be the sheriff of Cumberland and eventually the Earl of Carlisle, only to have his life snuffed out as a traitor to the Crown. His father was in the service of the Clifford family and it is known Andrew distinguished himself as a soldier in the Anglo-Scottish Wars that broke out in 1296. He assisted Robert de Clifford, Lord of the Marches, in the defence of further Scottish incursions and in 1311 was appointed sheriff of Cumberland. This was followed by becoming a Knight of the Shire in 1312 and warden of Carlisle Castle in 1313.

View of Carlisle showing the defensible position of the city.

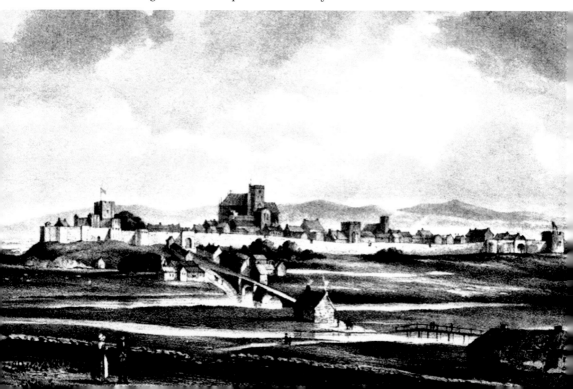

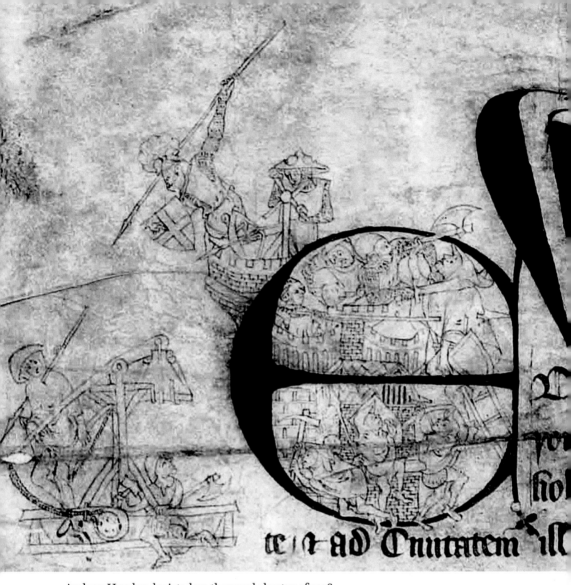

tc i a ad Cnntatem ill

Andrew Harclay depicted on the royal charter of 1316.

In 1315, Robert Bruce led his army into the north of England and from 22 July, he laid siege to Carlisle for ten days. Systematically and relentlessly they attacked one of the city gates for every day of the siege, and on occasion multiple gates at once, but the defenders fended them off using arrows, darts and spears. The besiegers were so beaten back by the amount of objects being hurled at them they 'wondered whether stones were breeding inside the walls'. Midway through the siege the Scots set up a machine to fire stones at the wall and proceeded to rain down stones in a constant barrage, but this did little damage to the wall and killed only one man. Inside the city were at least seven similar machines throwing darts and stones, all of which harried and injured the besiegers. Other Scottish siege towers built to attack the walls sank and stalled in the boggy ground outside the walls, becoming completely ineffective. At the end of ten days the Scots abandoned the siege and even left their

siege engines behind. Edward II was so pleased with his efforts Andrew was rewarded with 1,000 marks and Edward granted Carlisle a royal charter in 1316 – the charter has an initial letter which depicts Andrew throwing a spear at a Scottish soldier.

In late 1315 or early 1316, Andrew was captured by the Scottish, perhaps in a raid over the border, and held for ransom. Some records state he asked Edward II for help with the ransom, as he could not raise the amount himself, and was released once Edward had paid 2000 marks. Whatever the truth, he was soon back defending the north-west of England against further attacks, forays and skirmishes.

In March 1322, Andrew Harclay was made Earl of Carlisle after his success in commanding during the Battle of Boroughbridge, which was the final action of a lengthy dispute between King Edward II and his cousin, Thomas, Earl of Lancaster. Lancaster's forces were retreating from a defeat by the king at Burton-on-Trent, following the Great North Road, when they were blocked by around 4,000 men commanded by Harclay, the warden of Carlisle. He had taken up position on a narrow bridge over the River Ure and ironically using tactics similar to those of Robert Bruce at Bannockburn, he set up a defensive spear wall, protected by archers, to prevent the rebels from crossing. The Earl of Lancaster was captured and later executed.

Andrew took part in Edward's unsuccessful campaign into Scotland in 1322, but was unable to come to Edward's aid at the Battle of Byland when the king was almost captured near Rievaulx Abbey on 14 October. Edward II was a poor leader, prone to the promotion of favourites and continually failed to protect the north of England against the Scottish invaders. As a result, Andrew Harclay, emboldened by his elevation to

Part of the West Wall and Tile Tower.

Earl and the lack of confidence in the king, decided to try and end the war through a treaty with Robert Bruce. It was late 1322 and the Scots invaded via the Solway and stopped at Beaumont, 3 miles outside Carlisle, taking livestock and destroying crops. Harclay, without royal approval, made a peace treaty in which he and the Scottish king would be arbiters, the treaty being concluded in early January 1323. As soon as King Edward learnt of this breach of protocol Harclay was summoned to report to Edward but declined; the King then sent some local lords to arrest him. The local rivals were only too happy to rid themselves of this upstart and took the earl by surprise and arrested him in the great hall of Carlisle Castle. After a show trial he was condemned to a traitor's death by hanging, drawing and quartering, with his head to be displayed on London Bridge and the four quarters of his body to adorn prominent positions in Carlisle, Newcastle, Shrewsbury and York. He is said to have uttered 'You have divided my carcass according to your pleasure, and I commend myself to God,' as he was dragged through the streets, with his hands held aloft in prayer. He was then hanged, drawn and quartered on Harraby Hill, just south of the city, a place also known as Gallows Hill. There is an account of his head being sent to Knaresborough, where Edward was in residence, to enable him to examine his once loyal subject.

However you look at this story and the rise of Harclay to his great position, he seems to have been a capable military thinker and devoted protector of the north. His main problem seems to have been that he was around at the same time as a fickle and self-obsessed king, whose skill in the field did not match his ambition.

An interesting point is that the earldom of Carlisle remained dormant for almost exactly 300 years; James I reintroduced it in 1622 as a reward to James Hay who served in various positions at court.

I

Irish Gate (also known as the Caldew Gate)

The city walls included various gates or entrances based on the road pattern at the time and as in many walled towns, as horse-drawn coaches or motorised vehicles became the norm, these narrow defensive openings were believed to strangle free movement. Many were demolished – forever lost to history – and this was the fate of the Irish Gate *c.* 1811. Today the gate is represented by a curving footbridge that spans the modern A595 to the north of Carlisle and a brick-built arch-cum-tower over the pedestrian walkway. The gate was also known as the Caldew Gate and was connected to a bridge spanning the River Caldew. On the opposite site of the current archway, the dismantled end of the curtain wall is clear to see, as is the remaining west wall from the corner of the castle complex. These walls line up with the remaining West Walls heading to the south of the city.

West Walls remains near castle.

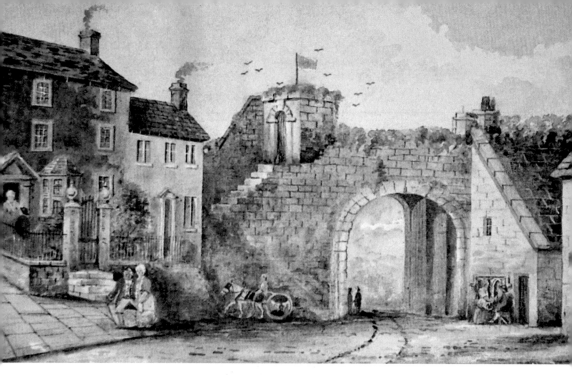

Above: The Irish Gate depicted before its demolition in 1811.

Left: Irish Gate today.

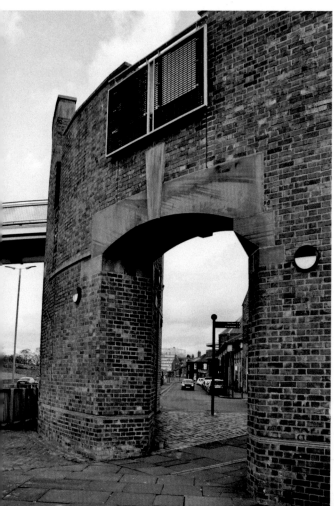

When the Scots besieged the city in 1315, after their victory against the English at the Battle of Bannockburn, the city walls were under attack including the Irish Gate. The *Lanercost Chronicle* reveals that the Scots 'erected an engine and continually threw great stones towards the Caldew Gate, but did no injury', and amazingly, some of these projectiles were found during building work on Annetwell Street in 1878. In 1385, it was reported to the Crown that the gates of the Irish Gate would not shut properly and records suggest it took forty-three years for a grant of £80 to be made for the repair of the gate. Later in 1563, the gate was again recorded as being in a poor state and it was Colonel Thomas Fitch, Governor of Carlisle, who ordered that the doors from a nearby demolished castle be hung in the Irish Gate.

The medieval wall follows the line of the Roman banks and it is William Rufus who is reported to have begun the building in 1092, but more likely they were built in stone from as early as 1130. The original structure had a small barbican that covered a drawbridge that spanned the city ditch or dyke, which probably surrounded the wall. The gate was said to be in good repair when Nathaniel Buck (the famed engraver and printmaker) visited Carlisle in 1738 to draw the walls and gates of the city. The current walkway and Irish Gate were constructed during the millennium and opened on 9 October 2000.

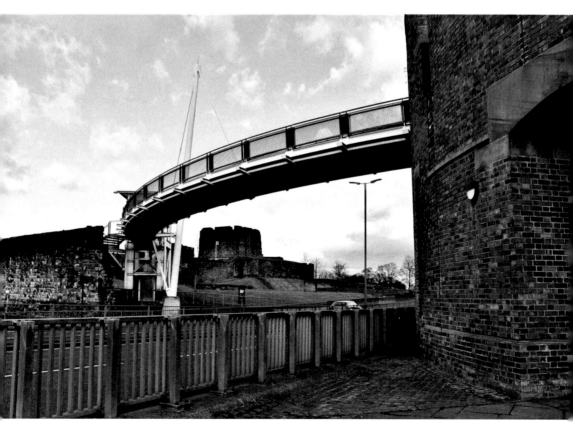

Irish Gate and walkway towards the castle over the A595 road or Bridge Street.

The Tile Tower

As mentioned above, the city walls date from the twelfth century and were built from sandstone blocks, some of which would have been retrieved from the existing Roman fortifications. The walls surrounded the old vicus, or town that grew up

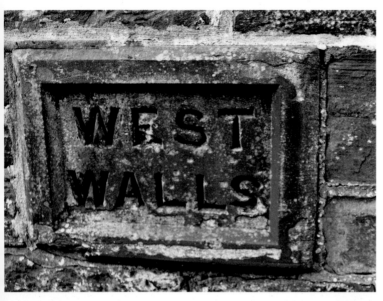

Left: West Walls sign.

Below: West Walls looking south.

around the fort, and towers were placed at intervals as guardhouses to gates or sections of wall. The towers project from the wall and allow the defenders to check the length of the walls for attackers. The Tile Tower is one of these interval towers and would have formerly guarded the Irish Gate. The rectangular tower, though part of the original twelfth-century fortifications, has been modified at different times from the fifteenth century to the eighteenth. Houses were built against part of the walls in the early nineteenth century and joist holes for floors can still be seen cut into the Tile Tower and wall. The last of the houses was demolished in 1952.

Other gates in the city walls include the 'Sally Port' on the West Walls, opposite St Cuthbert's, English Gate at the Citadel and Scotch Gate at the northern end of Scotch Street.

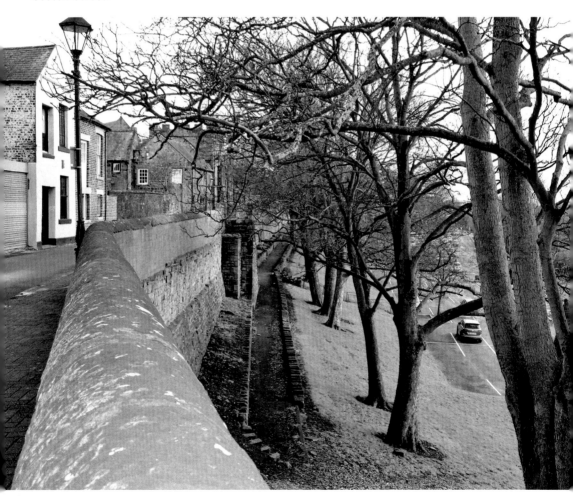

West Walls close to position of the Sally Port.

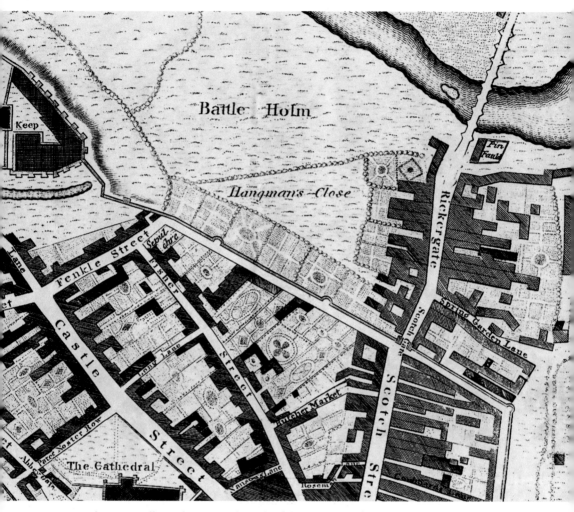

Map showing walls on the east and north of the city.

J

Jacobites (Bonnie Prince Charlie)

The city and castle returned once more to prominence during the Jacobite rising of 1745–46, which attempted to restore the exiled Stuarts to the throne of England. Prince Charles Edward Stuart (also known as Bonnie Prince Charlie) had landed in the Scottish Highlands and led his army south gathering supports as he went, reaching Carlisle on 9 November 1745. The city and castle surrendered five days later.

In 1689 the Catholic James II was overthrown in what became known as the Glorious Revolution and was replaced by William, Prince of Orange and Mary Stuart who ruled as joint monarchs. Whilst England supported the new regime, the feeling in Scotland was less than supportive, with many unhappy at the removal of the Stuart dynasty, which had united the Scottish and English crowns. During this period there were four major Jacobite rebellions: in 1689, 1715, 1719 and 1745. It was the last rebellion where Carlisle Castle saw action when the city and castle surrendered to Prince Charles Stuart on 14 November 1745. It was his victory at the Battle of Prestonpans on 21 September 1745 that facilitated his invasion of England.

On 9 of November, Charles Stuart and his army approached Carlisle, a city once considered a strong defensive position against Scottish incursion, but at this time its fortifications were now considered obsolete, nor had they been well maintained.

West prospect in the 1700s.

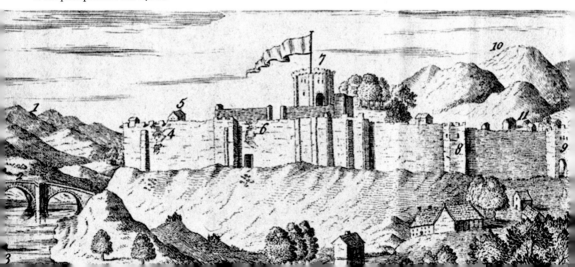

3

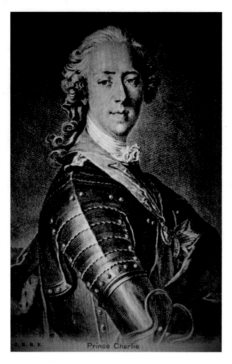

Portrait of Bonnie Prince Charlie.

Though Carlisle, learning of the prince's victory, had invested some time in preparing for the Scottish advance south, there was only so much that could be done to repel the attentions of a well-armed force. The city was still protected by the old castle and was still surrounded by an old but fairly decrepit wall, which could be manned by the townsfolk and the local militia, which had been raised in the counties of Cumberland and Westmorland.

On the 9th, a forward party of the Scottish army arrived on the Stanwick Bank to reconnoitre the city and were met by a few shots being fired at them from the walls. The next day the Scottish army crossed the River Eden at different points and surrounded the city before the prince sent a letter to the mayor, demanding he surrender the city without the need for bloodshed. The mayor who proudly proclaimed he was not Paterson, a Scottish man, but Pattison, 'a loyal-hearted Englishman', sent his reply in the form of a blast of his cannons towards the besiegers. The prince was advised that Marshal Wade and an army were marching from Newcastle to relieve Carlisle, and he felt it was crucial to meet these forces in the hills between the two towns. He divided his army, leaving a contingent to keep the pressure on Carlisle, but advancing towards Wade with the bulk of his forces as far as Brampton and Warwick Bridge before resting for the night. In *The Life and Adventures of Prince Charles Edward Stuart* by W. Drummond Norrie, published in 1900, he recants the story of the prince dining at Warwick Hall and he was entertained in the Oak Parlour by the squire's lady, a daughter of Thomas Howard of Corby Castle, who had been out in the rebellion of 1715.

The next day he discovered the rumours of Wade and his army were false, and sent back the Duke of Perth, with all haste and a body of men, to end the siege of Carlisle as quickly as possible. The men prepared siege equipment from the local woods and parks. The army prepared trenches, gun positions and barricades in earnest, with the Duke of Perth and Lord George Murray working alongside the men in the trenches to inspire them. Though the defenders continued to harass the besiegers with constant firing and abuse, they inflicted little damage. They were unsettled by the impressive works being carried out, daunted by the weaponry on show, and fatigued by the need for constant vigilance. The defenders felt to save destruction of the city they must capitulate and agreed that as soon as the Scots advanced to assault the walls, Mayor Pattison was to display the white flag from the walls to ask for terms of surrender. Upon the flag of truce, an agreement was reached and sent to Brampton for the prince to ratify, but he would not agree unless the castle was included in the treaty. This was reported to the garrison, and Colonel Durand, in command of the castle, acquiesced to these demands. On the morning of 15 November, the gates of Carlisle were opened and allowed the invaders to enter the city.

When the Duke of Perth entered the garrison, he shook them by the hands as he complimented them on their bravery, and asked them to join his forces to fight for the Stuart cause. The Jacobite's gathered all the arms and munitions, secured all the useful trappings of war, including horses and valuables. The next day Prince Charles was proclaimed in the presence of the mayor and aldermen, and was given a 'Declaration of the King's Majesty to his English Subjects'. The rebels were not well received and once they advanced south there were ongoing fracas between the rebel's garrison and the local populace.

On the day after the surrender of Carlisle, Marshal Wade, who was based at Newcastle, commenced a march towards the city but combined with the intelligence of Carlisle's fall and being unable to progress due to the amount of snow, he returned to Newcastle to await further instructions.

During the invaders' time at Carlisle, the first signs of dissention and cracks in the command began to appear. The rivalry between Lord George Murray and the Duke of Perth was exposed, ending with Lord George Murray being given chief command of the army. As they continued south, the prince gained little support for his Catholic cause, and eventually reached Derby before further indecision and disagreements led the invaders to retreat. They were being pursued up the country by the Duke of Cumberland at the head of an English army and a significant skirmish occurred at Clifton, just south of Penrith. This was the last battle to be fought on English soil. It was on 19 December that a skirmish broke out between the Jacobite rearguard and around 500 government dragoons. The losses were light with around twelve Jacobite soldiers killed and the government dragoons losing ten men, though one British dragoon is believed to have died in Clifton several weeks later. The dragoons killed in the battle are buried in the local churchyard and near to the churchyard gate is a stone commemorating the

skirmish. As the Jacobites evacuated Penrith their discipline was deteriorating, and they are said to have broken into houses and shops plundering whatever they could carry.

The prince and the bulk of the army arrived in Carlisle on the same day as the Clifton skirmish, and resolved to leave 400 men to cover their retreat. By 21 December the Duke of Cumberland arrived and took quarters at Blackhall. The duke brought up heavy artillery from Whitehaven and bombarded the castle, prompting the rebel leader to surrender by 30 December. The duke decided to stay at Highmore House, where the prince had also lodged, and plaques on the wall of the current building commemorate this event.

The castle became the prison for the rebels, where as many as 370 men were held in appalling conditions in the keep, and it is said they relied upon moisture seeping through the walls to stay alive. The duke marched on to intercept the Jacobite army

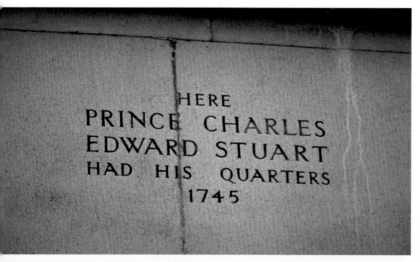

Charles Stuart stayed at Highmore House in Carlisle.

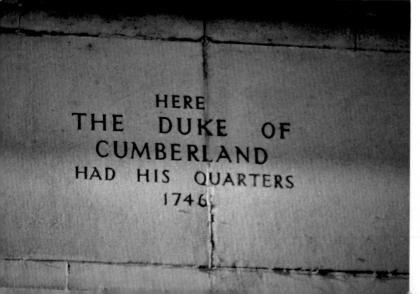

Duke of Cumberland stayed in the same place as he chased the Jacobites north.

at the Battle of Culloden (1746) where the remaining insurgents were defeated. Following the battle, the rebels and others were pursued throughout the highlands and persecuted if suspected of being a Jacobite.

The Rebellion led to a substantial number of trials for High Treason, with ninety-one sentenced to be hanged, drawn and quartered by a Special Commission at Carlisle. Of the ninety-one executions, twenty were to be carried out at Carlisle, six at Brampton and seven at Penrith. The names of the rebels executed in October 1746 at Penrith are as follows: James Harvey, Robert Lyon, David Home, John Rowbotham, Valentine Holt, Andrew Swan and Philip Hunt. The sentence carried out on these individuals is described below:

> That you be drawn on a hurdle to the place of execution where you shall be hanged by the neck and being alive cut down, your privy members shall be cut off and your bowels taken out and burned before you, your head severed from your body and your body divided into four quarters to be disposed of at the King's pleasure.

What may be more of a surprise is that the names don't appear to be very Scottish and this may be due to the fact that there was an English Jacobite Manchester Regiment. It should be remembered that the Jacobite cause was also part of the ongoing conflict between Catholics and Protestants, and as such still attracted dissatisfied English Catholics. This regiment was commanded by Francis Townley, who surrendered to the Duke of Cumberland after he held out against his forces for the ten days in Carlisle. The execution of Francis Townley carried out in London in July 1746 is described thus:

> After he had hung for six minutes, he was cut down, and, having life in him, as he lay on the block to be quartered, the executioner gave him several blows on the breast, which not having the effect designed, he immediately cut his throat, after which he took his head off then ripped him open, and took out his bowels and threw them into the fire which consumed them, then he slashed his four quarters, put them with the head into a coffin, and they were deposited till Saturday, August 2nd, when his head was put on Temple Bar, and his body and limbs suffered to be buried.

Robert Lyon, one of those executed at Penrith, was a Jacobite minister. Revd Lyon was chaplain to Lord Ogilvie's regiment and was captured at Carlisle, but all appeals for mercy were turned down by the Duke of Cumberland and he was executed with the others. Many of the rebels, Scottish and English, were 'transported' around the empire and the Jacobite cause struggled to threaten Britain again – though in 1759, at the height of the Seven Years' War, Charles encouraged the French to invade England with a sizeable French force to which he hoped to add a number of Jacobites. However, the prospect of invasion was ultimately thwarted by naval defeats upon the French by the British and later, in 1788, Bonnie Prince Charlie died in Rome, being buried in St Peter's Basilica in Vatican City.

Joseph Henry Collin

Joseph Henry Collin was born in Jarrow, County Durham, in 1893, but his family and his roots are firmly established in Carlisle. His father, also Joseph, an engine fitter, and his mother, Mary (née McDermott), were both from Carlisle. They married in Carlisle and had six sons as well as two daughters, and although Joseph Henry was born in Jarrow, all his siblings were born in Carlisle, which suggests they only lived in Jarrow for a short time.

Joseph Henry was educated at St Patrick's school on Albert Street (now part of Georgian Way) and at the outbreak of war, he was twenty-one years old and was working as an assistant salesman at Hepworth & Sons, tailor on English Street. Like many young men at the time he signed up to join the British Army and in 1915 enlisted in the Argyll and Sutherland Highlanders. He served with the Argyll and Sutherland Highlanders in France, and was promoted to Sergeant, before he was selected for a commission by the King's Own Royal Lancaster Regiment. He was posted to France in October 1917, now as a 2nd Lieutenant to the 1/4th Battalion.

On 9 April 1918 he was fighting at Givenchy when he was awarded the Victoria Cross in an action where unfortunately he was mortally wounded. The citation reads:

> For most conspicuous bravery, devotion to duty and self-sacrifice in action. After offering a long and gallant resistance against heavy odds in the Keep held by his platoon, this officer, with only five of his men remaining, slowly withdrew in the face of superior numbers, contesting every inch of the ground. The enemy were pressing him hard with bombs and machine gun-fire from close range. Single-handedly 2nd Lt. Collin attacked the machine gun and team. After firing his revolver into the enemy, he seized a Mills grenade and threw it into the hostile team, putting the gun out of action, killing four of the team and wounding two others. Observing a second hostile machine gun firing, he took a Lewis gun, and selecting a high point of vantage on the parapet whence he could engage the gun, he, unaided, kept the enemy at bay until he was mortally wounded. The heroic self-sacrifice of 2nd Lt. Collin was a magnificent example to all.

Joseph was only twenty-four years old when he earned his Victoria Cross, which was presented to his parents by the King on 25 July 1918. He is buried in Vieille-Chapelle New Military Cemetery, Lacoutre, France. He is remembered on memorials in both Jarrow and Carlisle and there is a blue plaque on his family house of No. 8 Petteril Terrace in Carlisle as well as a local road named after him. His Victoria Cross is on display at the King's Own Regiment Museum, Lancaster.

Above: Rickerby Park.

Right: Monument in Rickerby Park.

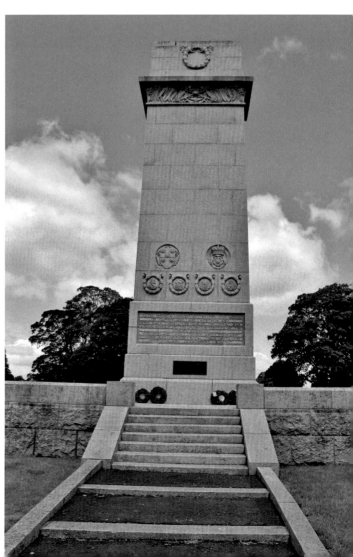

King's Own Royal Border Regiment

The King's Own Royal Border Regiment was an infantry regiment of the British Army. It had a relatively short existence from 1959 until 2006. It was formed at Barnard Castle on 1 October 1959 when the King's Own Royal Regiment (Lancaster) and the Border Regiment amalgamated. The official abbreviated form of the regimental title was 'King's Own Border' as part of the King's Division.

It was in 2004 when it was announced that the infantry would be restructured, and the King's Own Royal Border Regiment would amalgamate with the King's Regiment and the Queen's Lancashire Regiment to form the new Duke of Lancaster's Regiment (King's Lancashire and Border). The new regiment was formed on 1 July 2006, with the previously named King's Own Royal Border Regiment forming the 3rd Battalion.

The origin of the regiment goes back to the 1680s as the King's Own Regiment of Foot, and later in the 1700s as the 34th (Cumberland) and 55th (Westmorland) Regiments of Foot. These regiments served in the Seven Years' War (1756–63), the American War of Independence (1775–83) and during the Napoleonic Wars. The regiment went on to serve during the First Anglo-Chinese War (1840–42) and the Crimean War (1853–55) where honours were won and a captured Chinese flag is on display in Kendal Parish Church.

In 1881, these two historic regiments were amalgamated as part of the Childers Reforms to become the Border Regiment. The Border Regiment went on to serve in the Second Anglo-Boer War (1899), the First World War (1914–18) and the Second World War (1939–45). During the First World War the regiment raised a total of sixteen battalions and was awarded five Victoria Crosses during the war. It served at Ypres, Gallipoli and Passchendaele to name but a few actions. The Second World War saw the regiment take part in the British Expeditionary Force that was eventually extracted from Dunkirk, and later the battalions served in most theatres of the war including North Africa and Burma. 1st Battalion trained as airborne and were involved in the Battle of Arnhem during Operation Market Garden in 1944.

Following the 1959 amalgamation, the regiment saw extensive service in Ulster during the Troubles in Northern Ireland, and were twice awarded the Wilkinson's Sword of Peace for work in both Derry and Bosnia (where it also served twice). The

regiments also served in Iraq in 2005–06, before becoming the Duke of Lancaster's Regiment in June 2006. The Duke of Lancaster is one of the titles held by Her Majesty The Queen.

The history of the regiments is on display at the King's Own Museum in Lancaster and the Border Regiment Museum in the Alma Block of Carlisle Castle.

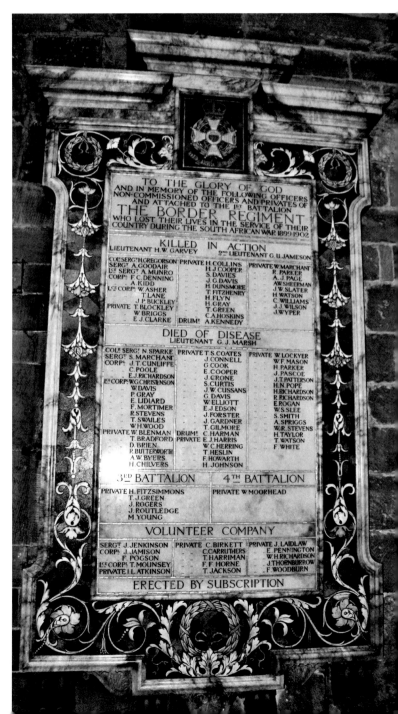

Memorial to the South African War (1899–1902) in the cathedral.

 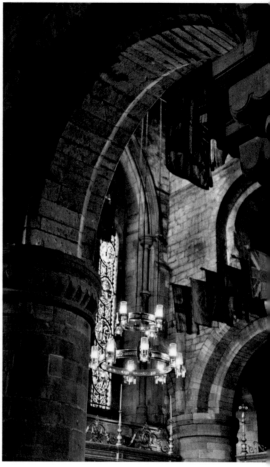

Above left and right: Border Regiment chapel.

L

Luguvalium

Luguvalium is the name the Romans gave to the settlement and fort that was established by Quintus Petillius Cerialis *c.* AD 72 as they pressed their invasion north from Chester and York. The Roman invaders subjugated the northern tribes called the Brigantes, who mainly inhabited the Pennines, Durham and Yorkshire, and the Carvetti, who inhabited the North West including what is now Cumbria. The fort is now predominantly beneath the medieval castle and its vicus (or supporting settlement) grew up to the east of the fort. It was obviously located here to guard the strategic crossing over the River Eden and then it became an important outpost to support Agricola's invasion over the years AD 78–84 into what is now Scotland.

Hadrian's Wall halfway between Carlisle and Newcastle at Crag Lough.

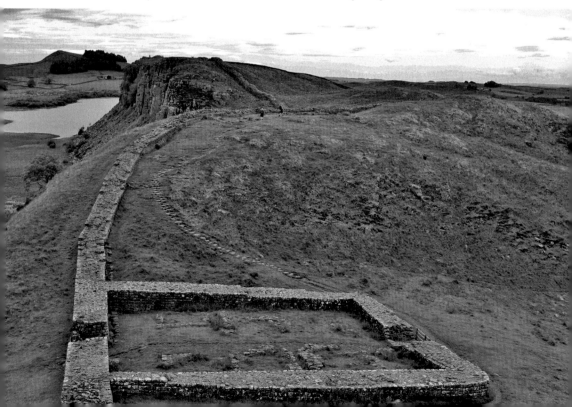

The evidence suggests that up to three timber forts were built on the site: the first in AD 72, the next in AD 78 and another sometime around AD 103–05. The site of the fort lies partly buried beneath the superstructure of Castle Keep, with the south-eastern corner and extensive lengths of the eastern and southern ramparts surviving intact but buried, between the castle and the A595 Castle Way Road. These buried sections of the fort have been investigated by many archaeologists who have developed a very detailed picture of the sequence of forts that were built upon the site – an incredible task considering they were all built more or less on top of each other, and although the exact dimensions cannot be verified, experience and evidence suggests an area of around 8 acres (3.2 hectares).

The Carlisle site was obviously eclipsed in importance during the Hadrianic period once Hadrian's Wall was built from AD 122, and the establishment of a large auxiliary cavalry fort at Stanwix, which was built on the wall just to the north-east of Carlisle. The early fort's importance diminished and though garrisoned, it was abandoned during the Antonine period (the Antonine Wall crossed the narrow part of Scotland between the Firth and the Clyde) from AD 140 to AD 193. However, by the third century Luguvalium was once again an important military base on the Roman frontier after the withdrawal from the Antonine, and was a centre of administration as principal town of Civitas Carvetiorum (self-governing territory of the tribal group known as Carvetii). Another fort was built of stone on the same site around AD 200 by soldiers from the 20th Legion, which was finally abandoned sometime between AD 275 and AD 325.

Inside the abbey complex.

Old window in the cathedral.

When the Roman forts were garrisoned, the vicus or town would have serviced the soldiers and expanded along the main routes, which in the case of Carlisle appears to have been mainly north and south. After the Roman's left Britain, the town appears to have continued to prosper and a Romanised population survived into fifth century. Its ancient British name is supposed to have been 'Llugyda-gwal' meaning the 'Army by the Wall', and in the writings of Bede it is called 'Luguballa'. One explanation for the name 'Lugu-vall-ium' is said to signify 'fort on the water'. The name was later abbreviated by the Saxons to 'Luell', which when added to the Saxon word 'Caer', meaning city, became 'Caer-Luell' or, eventually, Carlisle.

Evidence suggests there was an Anglo-Saxon monastic community here in 685, possibly centred where the cathedral now stands. According to 'Life of St Cuthbert', Carlisle and a territory of 15 miles' radius were granted to the saint by the king of Northumbria and when Cuthbert visited Carlisle there was a fountain of some sort still functioning. This community is said to have been destroyed by invading Danes c. 875 and to have remained abandoned until after Norman conquest, though there is some archaeological evidence to suggest some occupation during the tenth and eleventh centuries.

Margery Jackson

Margery Jackson was born in Carlisle in 1722 and baptised at St Mary's Church on 22 February of that year. She was the only daughter of Joseph, who was a merchant, and Isabella, who was the daughter of William Nicolson, a cousin of the Bishop of Carlisle (1702–18), another William Nicolson. Her grandfather was Thomas Jackson, known as 'Trooper Tom', who served in the Parliamentary army during the Civil Wars and he had owned some land, so when he had died around 1700, the inheritance had ended up with her father, Joseph.

When Joseph Jackson died in 1732, he possessed substantial estates and property, which he left to his widow and four children, the eldest son, William Nicolson Jackson, and younger boys Joseph and Jerome. Margery was the youngest, but all the last three children were under age. His will gave all his estates to his eldest son and to his other

Looking towards the marketplace from the south.

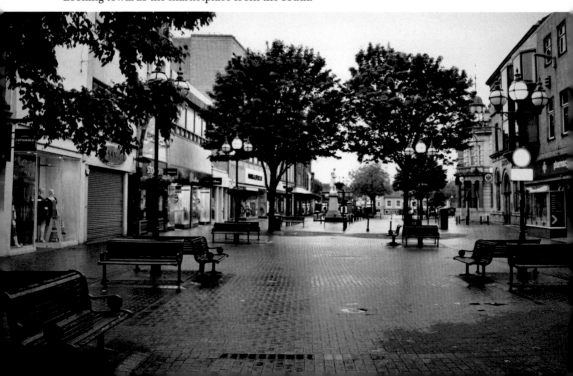

three children a legacy of £1,000, to accrue interest during their minority. To his wife was left all of his personal property, though she died within the year and left further property and monies to all the children, with the eldest appointed executor.

Now in the care of the eldest, the younger children did not seem to fair well. Joseph died at the age of twenty-five, possibly in the army, and Jerome died at the tender age of twenty-three, but Margery seems to have been brought up and educated by her cousin, Thomas James, or his sister, Elizabeth James. She seems to have been raised in the same manner as other young females at that time, and attitudes later in life do not seem attributable to this stage of her upbringing. William Nicholson Jackson married but did not have any children. He had become a clergyman and had at times been elected mayor of Carlisle, so was an important local man who now lived in a large house in the marketplace.

Margery and her brother never had much love for each other and she accused him of monopolising the assets of their deceased brothers and claimed she was due an equal share. Following a prolonged argument she 'filed a Bill in Chancery against him to compel him to account for the personal property of her parents, and to pay the legacies given by their wills'. In 1776, whilst this process was pending, William Nicholson Jackson died and in his will he left to Margery a mere annuity for her life payable out of his large property. In a final act of disdain for his fifty-four-year-old sister, he left the property to her children – if she ever had any, otherwise it went to a Thomas Hodgson, who was a distant cousin.

An incensed Margery, though poor, placed her case in the hands of Mr Robert Mounsey from Holborn in London, because of a complete lack of trust in any of the Carlisle attorneys:

> For year after year she sat over him, a morose, hard-featured, flinty-hearted, creature; no ways resembling a woman in anything but dress – and in that like none other, with one sole pursuit – the prosecution of her claims – one sole amusement in watching the progress of her case in Court, before the Master, and in her solicitor's office.

This condition was to dominate the next sixteen years of her life and an often-told tale to confirm her singular determination is the story of her 300-mile journey from Carlisle to London over Stainmore, alone and on foot.

She pursued her suit against Mr Thomas Hodgson until he died, young and unmarried, in 1788. He left all his property to be divided amongst his numerous cousins who knowing Margery's determination, wanted to compromise with her. In 1791, the cousins accepted £100 each, and she agreed to pay the costs of the suit, but the whole of her brother's property became hers. In the same year she returned to Carlisle to take possession of the family house but arrived in her brother's carriage. She discovered the case had made her unpopular with the locals and she was without friends, but she did not help the situation with her miserly and eccentric behaviour that followed.

Postcard showing Stainmore, the old Roman route over the Pennines.

The carriage that brought her was pulled by two fine bay horses but she never used them again; instead she lavished her affections on the creatures with 'her frequent exclamations of fondness, and her exclusive liberality towards them'. Yet her large home often appeared deserted, with most of the dirty windows closed and shuttered – she once had them cleaned and the occasion was so unusual it was recorded in the local newspaper.

It seems from the reports that servants did not last long in her company and visitors to the house were few and far between. Her house was said to be elegantly furnished but in an old-fashioned style, but this mattered little as she mainly lived in her front parlour where there was a fireplace but with the kitchen filled with its ashes. When she walked her dog, if it was lucky enough to find a bone she would keep others away with a stick until her dog had its fill. She seems to have enjoyed a drink, her favoured tipples being brandy and port wine, to which she referred to as Doctor Port and Doctor French. She also had an aversion to children and when tenants applied for rooms at her many houses she used to say, 'How many toads have you?', meaning children, and often rejected those that had large families. She was often the object of ridicule and torment by the children as she walked the street 'in her grey duffle habit, more like a beggar than a lady of property', and would shout at people of standing, 'Trash! Trash! upstarts! tradesmen's wives, with their pockets stuffed with money, raising prices in the markets! Trash!'

A description of Margery refers to her as of 'middle stature, thin, sallow, and shrivelled, with a most forbidding aspect' and even in the heat of summer she dressed in an old, washed-out yellow gown, with a yellow-white petticoat. On top of this would be a blackish silk cloak in a very old fashion, but her favourite and general dress was her old grey duffle coat with the bottom wearing away from being dragged along the roads and paths. She always carried in her hand a gold-headed cane, which could be used to chase the children away. Generally, she always wore old clothes, washed-out and threadbare, and in later years she had a beard.

She was known to be a supporter of the Tories; on the eve of an election she decorated her windows in the yellow and blue of the party colours and even appeared in a gown of the same colour. She was known to stand fearlessly against an angry mob by openly displaying her political views. She also hardly ever attended worship even though she

had a seat at St Cuthbert's. This may have been due to her disagreements with her family in the clergy. She abhorred banknotes and would always take her rents from her tenants in gold and silver, paid at the open parlour window, and kept the coin in an iron chest under her watchful eye.

She did have one loyal friend, Joseph Bowman, who was her business manager for forty years. He inherited her fortune by an extraordinary will, which she signed just before her death. It was at Christmas 1811 when she became unwell; her voice no longer screeched, she took no brandy and only survived on milk and slops (a kind of milky oatmeal). She could not make it to her bed and remained in her chair until the end of January when she was paralysed and her head sunk on her chest. She died on 6 February 1812, at the ripe old age of ninety. She left property and money to the amount of around 50,000 pounds, including her iron chest full of gold and silver.

Margery Jackson was buried in her grandparents' grave in the grounds of Carlisle Cathedral. Hundreds attended her funeral out of curiosity, to get a last glimpse of the 'Miser of Carlisle'.

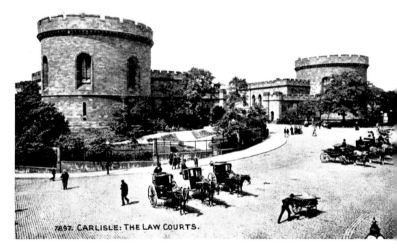

Old postcard of the Citadel.

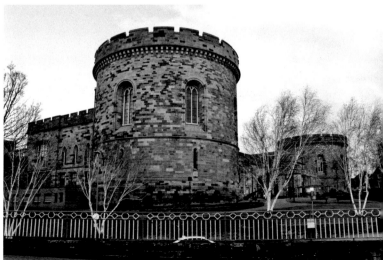

A Citadel tower.

Nisi Prius Courthouse – The Citadel

By the time of Henry VIII the southern defences and entrance to the city were deemed insufficient and in need of strengthening. The Crown identified Stephan von Haschenperg as the man to update the castle (see the letter C) and to modernise the old southern point of entry to the city known as Botchergate or English Gate. The Citadel was built in 1541–42 and consisted of a triangular enclosure with massive round towers situated at the angles. As the name suggests, the Citadel was designed to

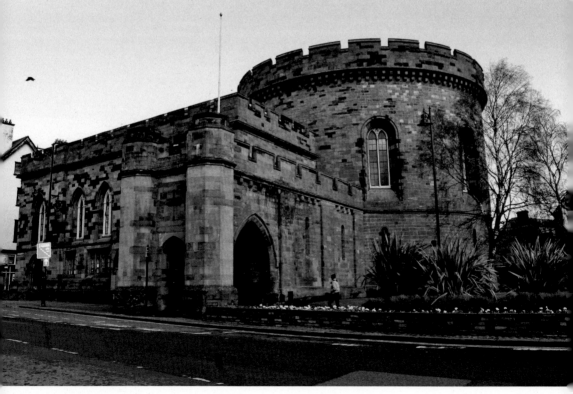

The Citadel gate.

be independent of Carlisle's other defences and able to hold out to attack without the mutual support of some of the now obsolete defences of the city. It was also fortified on its northern side, the side facing into the city, and a half round tower was constructed as an arsenal to ensure self-sufficiency during an attack.

Some remodelling of the old defences was carried out to allow for the installation of gun ports, replacing the old medieval-style defences. On the west side a rectangular tower was built to mount further guns on the defensive structure. To either side of the main entrance were erected two large, round fortifications, two storeyed and 60 feet in diameter, with 12-foot-thick walls. Built within these were casemates mounting more artillery. The Citadel was connected by curtain walls and to allow passage to and from the city a new gate, called the English Gate, was included in the Citadel design. These were the last days of the castle in history and a few years after the accession of James I and unification of the Scottish and English crown, the Citadel was mainly used as a gaol.

In 1810, the fortress was almost completely demolished to create the present complex and only the lower level of the eastern tower remains. In the spirit of the Henrician complex, the new Citadel, designed by Thomas Telford and built by Sir Robert Smirke, followed a similar design with two massive circular towers constructed in red-sandstone ashlar with battlemented parapets. The building also served as civil and criminal courts as well as the city gaol.

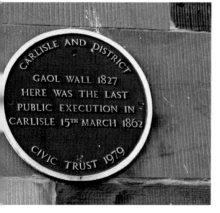

Above: Old gaol plaque.

Right: The Citadel at night.

Old Grapes Lane and the Other Old Lanes

The Lanes Shopping Centre was built in the mid-1980s over an area to the east and north-east of the marketplace formerly occupied by narrow alleyways of housing and small shops referred to locally as The Lanes. The map below, *c.* 1820, shows the layout of the lanes sandwiched between Scotch and English Street, and Lowther Street.

Map of old lanes, *c.* 1820.

Lowther Street used to be called Drovers Lane and marked the extent of the city and the eastern city walls. The housing and shops built in the lanes would have run west to east to the city walls and hardly altered in layout since the medieval period. The inhabitants are described as poor and the shops as struggling to make a living, with many buildings in a poor state of repair. Over the years there were various reviews of the area and solutions submitted, but in the end the whole area was developed. John Laing Construction undertook the project and the whole indoor shopping precinct was completed in two years.

Some of the old names were incorporated into the development but the list was extensive and many named after inns: Packhorse Yard, Kings Arms Lane, Peascods Lane, Old Grapes Lane, Crown and Anchor Lane, Lewthwaites Lane, Old Bush Lane, Globe Lane, Union Court, Hodson Court, Keys Lane, Laws Lane, Bousefields Lane, Three Cannons Lane, Longcase Lane, Drovers Lane, Globe Lane, Lion and Lamb Lane.

The city centre of Carlisle was pedestrianised in 1989 and is now a vibrant and compact shopping area. The centre of Carlisle still retains independent shops, restaurants and bars.

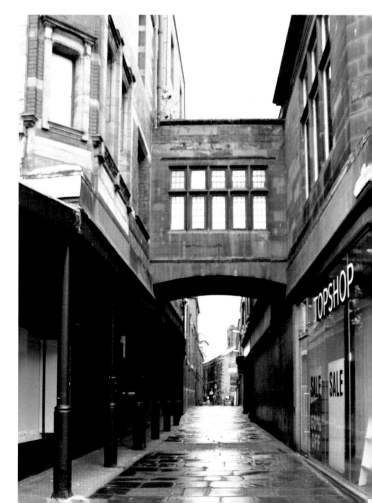

A lane on the opposite side of the marketplace.

Prehistory

Though there is not a great deal of evidence for prehistory in Carlisle itself, there are many Iron Age forts and ancient standing stones further south in Cumbria. But Carlisle can boast two amazing finds. In 2009, when Oxford Archaeology North excavated in the River Eden flood plain to the west of the village of Stainton, just before

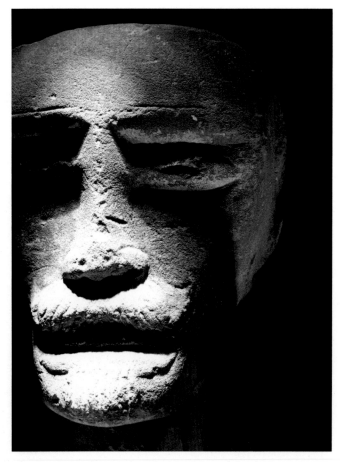

Stone face in the Tullie Museum.

the Northern Development Route was built, they discovered two very rare wooden 'tridents' thought to be around 6,000 years old. They were made from planks of oak and had handles to make them nearly 2 metres long. One similar wooden trident had been found before but this was in Ireland and archaeologists are not sure what they were used for.

At this time the landscape would have been very different and in all likelihood the River Eden and the estuary towards the Solway would have been a series of channels. This flood plain landscape would have been interspersed with a series of islands and ponds ideal for trapping or catching fish. It is thought these tridents may have been used in the fishing methods of the time but this is only conjecture. Some Neolithic people would have found this land advantageous to live in, with a reliable food source, easy transport links via the waterways and the shallow waters would have been easy to cross if required. Some people during this period built raised wooden walkways. These would principally link the island communities and many have been found intact, especially around fen areas. The forks were found under a platform and may have been placed there, or could have been lost after drifting underneath. It seems the site was abandoned in the Late Bronze Age, possibly because of silting up or clogging up the channels by materials flowing downstream and the river would have been less useful to the population.

The tridents were carefully preserved by a freeze-drying process, then, the water remaining in them was replaced with a waxy conservation fluid. The Tullie House Museum has them on display alongside other items found in the area, for example some Langdale axeheads and flint arrowheads.

Queen of Scots

Mary Stuart or Stewart, also known as Mary, Queen of Scots, returned to Scotland on 19 August 1561 after living at the French court since 1548 and marrying Francis, heir to the French throne, in 1558. Francis died prematurely in December 1560, making her a widow at the age of eighteen. She was a Catholic returning to a Protestant country, but at first Mary rules well, with the support of her natural half-brother James, Earl of Moray, and her policy of religious tolerance.

Things started to go wrong following her marriage to her cousin Henry Stewart (Stuart), Earl of Darnley, son of Matthew Stewart, 4th Earl of Lennox, in July 1565. Many disapproved of the marriage including James, Earl of Moray, and Darnley was a man of weak character, arrogant and feckless but ambitious. Over the next couple of years murder plots and intrigue plagued her rule. Her aid, David Rizzio, was killed by Darnley and some other nobles, then Darnley was found strangled after his house had blown up. Suspicions were raised about Mary's involvement after she was involved in an adulterous affair with James Hepburn, 4th Earl of Bothwell, during this period.

Events moved at pace after she married Bothwell in a Protestant ceremony on 5 May 1567 and in June at the Battle of Carberry Hill, Mary was captured and sent to Loch Leven Castle. Bothwell escaped but was in exile and then imprisoned until he died in 1578. On 4 July, Mary was forced to abdicate in favour of her young son, who became James VI of Scotland, later James I of England (but that is another story) under the regency of her half-brother, the Earl of Moray. In early May 1568 Mary escaped and headed west to her remaining supporters, determined to restore her rights as queen, but she was defeated at the Battle of Langside on 13 May.

On 16 May, she and sixteen supporters made the four-hour crossing of the Solway Firth arriving at the port of Workington in the early evening. The following morning Richard Lowther, the deputy governor of Cumberland, escorted Mary to Carlisle Castle. In the eyes of the English, Mary's intentions were uncertain at this point and though she had come to England of her own free will, she was placed under armed guard. She was housed in what was then known as the Warden's Tower, in the south-east corner of the inner ward, later known as Queen Mary's Tower – records show that it was one of the oldest parts of the castle and was the original Norman entrance.

Queen Elizabeth was anxious to ensure this Catholic queen in her kingdom was kept under control and sent Sir Francis Knollys, one of her trusted courtiers, to Carlisle Castle to keep a wary eye on Mary. Sir Francis found his prisoner a charming person and indeed came to like and respect this Scottish queen. Sir Francis lived with the fear that Mary would escape and though he granted her certain privileges, including letting her walk on the grass in front of the castle (known later as 'the lady's walk'), his fears were raised when on one occasion whilst out on horseback to hunt hare she galloped 'so fast upon every occasion' that he said this could not happen again.

She would constantly implore Elizabeth for help having arrived with only a handful of attendants, and Mary was allowed to send for many of her old staff, as well as her own clothing. Fairly quickly cartloads of her clothes and personal effects arrived from Loch Leven. The queen had cut off much of her hair after the Battle of Langside in an attempt to evade being recognised, but one of her ladies-in-waiting called Mary Seton styled it so skilfully that 'every other day-lighte ... she hath a new devyce of head dressing'. She borrowed money from some of the Carlisle merchants to help her keep up her royal appearance, though much of the cost of maintaining her little court fell mainly on Queen Elizabeth. The English queen would pay an average of around £56 a week for her food, clothing and heating, as well as paying for her gaolers and guards.

The tower where she was held was demolished in 1835 when it was on the verge of collapse and all that now survives is an octagonal turret housing a staircase that once gave access to this tower.

In July, Mary was moved from Carlisle to Bolton Castle in Yorkshire due to the threat of influencing Catholic families in the north to release her and use her person to rally support in a return to the old religion. The journey is supposed to have taken two days with an overnight stay at Lowther Castle near Penrith and Wharton – though it is amazing the number of places that claim to have housed her on her journey south. In early 1569 she was moved to Tutbury Castle in Staffordshire, but it seems she foolishly continued to involve herself in intrigue and plots. She was later taken to Fotheringhay Castle, and on 13 October 1586 she was tried for treason. Though she protested her innocence, after nineteen years in captivity and much soul searching by Queen Elizabeth, Mary, Queen of Scots was executed by beheading on 8 February 1587.

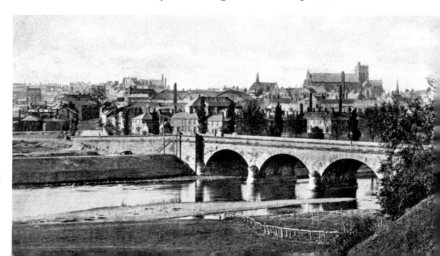

Colourised postcard of Carlisle.

Rufus, King William II

At the time of the Norman invasion, Carlisle was part of Strathclyde following Malcolm I's support of the Saxons at Dunmail Raise in AD 945 and he received the area now known as Cumbria as reward for his allegiance. A deal was agreed with Edmund of England to retain sovereignty over the region in return for defending northern England from the Vikings. This agreement was upheld following the Norman invasion, though the Scots under Malcolm III had tried to take advantage during the northern rebellion against the Normans. The retribution on the north became known as the 'Harrying of the North', where great devastation to the population and land was carried out by a vengeful William I.

By 1072, the rebellion had been crushed and William's position was once again secure, so he ventured north with an army and a supporting fleet. The Scots were defeated by William in battle at Abernethy on the River Tay, and Malcolm sought fealty, even handing over his son Duncan as a hostage. There were further incursions into Northumbria but in 1080 William sent his son Robert Curthose north with an army while his brother Odo punished the Northumbrians again. Malcolm III again made peace, and this time kept it for over a decade.

In September 1087, William I of England and Duke of Normandy died and his son William, known as Rufus, inherited the crown of England while his elder brother Robert Curthose (meaning short shanks) inherited Normandy. The younger brother, later Henry I, inherited a sum of money. William II of England was crowned within three weeks at Westminster Abbey as he was aware his elder brother Robert felt he should have inherited both England and Normandy.

William's uncle, Odo of Bayeux, and Robert Curthose led a rebellion of barons against William Rufus, and made their base at Pevensey Castle, but William successfully lay siege to the castle until those inside capitulated. Odo and Robert were banished to Normandy.

Further disputes over the Cumbrian border with William Rufus led to further raids by Malcolm III with his Northumbria allies. William Rufus decided to partition the county into Northumberland, Durham, Yorkshire, Westmorland and Lancashire to make it more manageable. In 1091, William Rufus invaded Normandy and took more lands from his brother Robert and Malcolm III tried to take advantage of the dispute and invaded England in support of Robert Curthose. After his successful campaign in Normandy William Rufus agreed the Treaty of Caen with his brother and returned

to England to deal with Malcolm III. He marched north with an army but the Scots retreated to Scotland. A peace was agreed and Malcolm III was forced to pay homage to William II, who took Cumbria for his troubles.

In November 1093, William Rufus became ill and was thought to be dying. Malcolm III advanced again into England and laid siege to Alnwick in Northumberland. An English force led by Robert de Mowbray, Earl of Northumbria, arrived to relieve the siege and in the subsequent fighting Malcolm III and his son were killed. Malcolm's brother Donald became King of Scotland.

It was during this background that the first castle at Carlisle was built over a section of the Roman fort. Following the victory over Malcolm III and his supporters, William II (William Rufus) set about building a fortification to discourage further incursions to his newly won lands in the north. The first fortification may have been a simple enclosure of earth and timber, using the natural landscape and the old Roman defences. Later William's younger brother, Henry I, visited Carlisle in 1122 and ordered that it be 'fortified with a castle and towers'. This is believed to be the origins of the massive keep, and it is known these works were still in progress *c.* 1130.

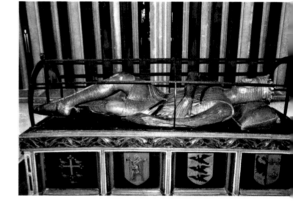

Right: Tomb of Robert Curthose in Worcester Cathedral.

Below: Hallmark Hotel, originally the Station Hotel.

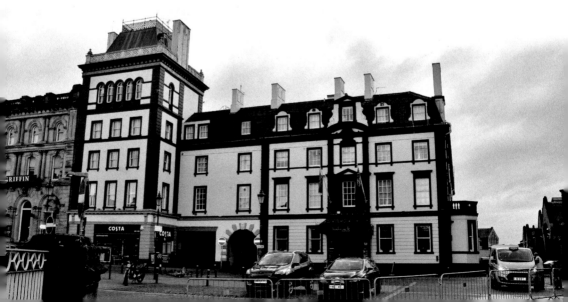

State-run Public Houses and Inns

Around 10 miles from Carlisle is Gretna, a town just over the Scottish border and once home to HM Factory Gretna, the largest munitions factory in the world during the First World War. It was a report from the front that highlighted a serious lack of ammunition for the British soldiers in France and the government decided something

Connell & Pattison Brewery shown on 1820 map.

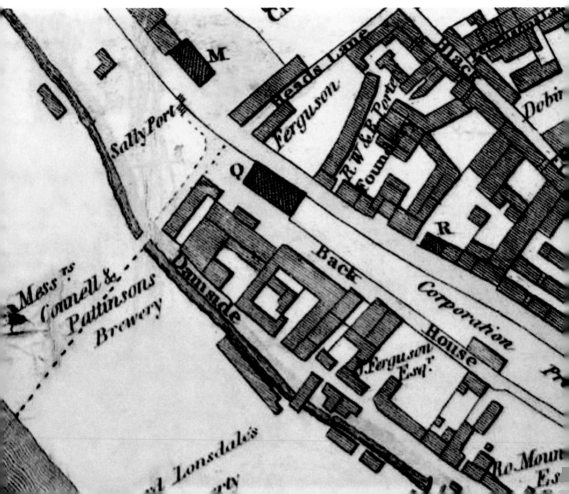

needed to be done. Lloyd George was appointed the Minister of Munitions and championed the construction of a munitions factory on a 9-mile rural site stretching from Longtown in England to Dornock in Scotland. It was in autumn 1915, when more than 10,000 navvies, mostly Irish, arrived in the area to begin the construction of the factory. The factory was pushed to begin production and by April 1916 the munitions started to be forthcoming.

The navvies were on high wages and at the end of the day had a thirst to quench. Luckily for them Carlisle had a great many public houses and inns, not to mention almost 12,000 young women from all around Britain drafted in to work at the munitions factory. This meant the pubs were filled to the rafters. Further to this there was a worry that Irish nationalism, on the rise on the streets of Dublin, would spill over to this drunken mob and there could be no rebellious actions in such a sensitive environment.

Alcohol and its consumption must be controlled, so in an attempt to reduce this licentious behaviour many pubs and breweries were shut down and those remaining were managed by civil servants. The government took ownership of Carlisle's public houses and suppliers of drink to impose a few changes to the industry. The strength of alcohol was reduced and opening times were restricted, a practice brought into the whole country to end the risk to industrial production throughout the war. Games and recreation were encouraged to turn men from the drink, and bowling greens became a common feature of some pubs.

State management in Carlisle lasted until 1973 but national licensing hours remained in place until finally changed in 2005.

Shown above is the Hallmark Hotel (originally the Station Hotel), a grand railway hotel designed in 1852 by Anthony Salvin. Salvin was considered one of the most eminent architects of the day and was involved in the refurbishment of Windsor Castle, as well as the more local Greystoke Castle near Penrith.

It is interesting to note the number of public houses and inns in Carlisle in 1847 when the population stood at *c.* 55,000. At around 138 pubs in 1847, that equates to a pub for every 399 people, a percentage of which would be children. Here is a list of the inns, taverns and landlords of Carlisle from the 1847 *Gazetteer*:

Andrew Marvel, Isaac Newton, 21, Botchergate
Angel Inn & London Tavern, Aaron Martin, 77, English Street
Barley Stack, Jerh. Irwin, 14, Rickergate
Bird in Hand, Andrew Lockie, 4, Castle-st.
Black Lion, David lvison, 2, Irishgate brow.
Black Swan, George Scott, 57, Castle Street
Blue Bell Inn, Robert Mounsey, 49, Scotch Street
Blue Bell, Joseph Trimble, 36, Rickergate.
Bowling Green Inn, John Carruthers, Spring Gardens
Bull and Dog, Andrew Johnston, Peascod's Lane
Bush Hotel & Posting House, Breach & Jeffery, English Street

Captain Cook, Sarah Creighton, Scotch Street

Carlisle Cross, Jonh. Bowman, 30, Fisher Street

City Arms, John Martin, St. Cuthbert's Lane

Coach &-Horses, Joseph Hall, 6, Blackfriars Street

Coachmakers' Arms, Joshua Ogelthorpe, 9, Rickergate

Cross Keys, David Little, Peascod's Lane

Crown, David Baxter, 11, Henry-st.

Crown, Mary. Robinson, 105, Botchergate

Crown & Anchor, Wilfrid Kirkup, Crown & Anchor Yard

Crown & Mitre & Coffee house, Hotel & Posting House, Wm. Jarman, 80, English St

Cumberland Ranger, Mary Graham, Shambles.

Dog & Duck, Jason Ward, Peascod's Lane

Drover, E. Darling, Bridge End

Duke's Head, Wm. Johnston, 51, Scotch Street

Duke of York, John Bowman, Ferguson's Lane

Duke of Wellington, Robt. Bainbridge, St. Cuthberts Lane

Earl Grey, Ann Armstrong, London road

Fish, John Thompson, Ferguson's Lane

Fish & Dolphin, John Reid, St. Cuthbert's Lane

Fox & Grapes, James Irving, Irish Dam side

Fox & Hounds, Wm. Smith, 8, Rickergate

Free Mason's Arms, William Sewell, 7, Annetwell Street

George & Dragon, John Bell, 18, Rickergate

Gleaner, Peter Hodgson, 2, Old Grapes Lane

Globe Inn, Mary Murray, 28, English Street

Globe, George Armstrong, Caldew Bridge

Golden Lion, Wm. Miller, St. Cuthbert's Lane

Grapes, Mary Armstrong, Scotch Street

Green Dragon, Sarah Pickup, 45, Scotch Street

Green Dragon, Robt. Cowen, (&farmer) Newtown

Gray Coat, Christopher. Bulman, 66, English Street

Half Moon, Jason Gilkerson, 15, Fisher Street

Hare & Hounds. Rbt. Ward, 10, Rickergate

Hare and Hounds, Joseph Richardson, 145, Botchergate

Highland Laddie, Ed. Hope, 11, Rickergate.

Horse & Farrier, Jason Brown, Raffles

Horse & Farrier, John Armstrong, Bridge-end

Joiners' Arms, James Roy, Church Street

Joiners' Arms, George Little, 53, Scotch Street

Jolly Butcher, Henry Little, 30, Botchergate

Jolly Guardsman, William P. Stubbs, Pack Horse-lane

Jovial Butcher, H. Little, Botchergate

Jovial Hatters, J. Nicholson, Caldew brow
Kings' Arms, Eliz. Donald, 71, English street
Kings' Head, Jas. Sawyer, sen. 19, Fisher street
Lancer Inn, James Scott, Gallow hill.
Letters, Sarah Hope, 8, Saint Alban's row.
Light Horseman, Jno. Poole, Rickergate.
Lion & Lamb, Jcb. Milburn, court, Scotch-street
Lord Brougham, Thos. Carr, 8, Henry street
Lowther's Arms, John Kennedy, Head's lane
Malt Shovel. Jas. Gilbertson, 40, Rickergate.
Mason's Arms, Thomas Phillips, 26, Blackfriar's street
Mason's Arms, T. Todd, John street
Minerva, James Rennison, Shaddongate
Moulders' Arms, Rich. Kirkbride, 150, Botchergate
New Inn, Joseph Hibbert, Backhouse walk
Odd Fellows' Arms, John T. Hills, 8, lrishgate brow
Odd Fellows' Arms, John Hodgson, 26, Fisher street
Old Anchor, Jno. Taylor, 18, Bridge street.
Old Black Bull, Rd. Johnson, 16, Annetwell street
Old Bush, John Atkinson, ct. 31, Scotch street
Old Queen's Head, John Watson, Caldewgate
Old Queen's Head, Isc. Peel, 4, St. Alban's row
Old Ship, Jacob Rowell, Irishgate brow
Ordnance Arms, Mary Smith, Finkle street
Pack Horse, James Weight, New Town
Pack Horse, Robert Brown, Water street
Pine Apple, Christiana Bell, 43, English street
Plume of Feathers, George Kinghorn, Scotch street
Quarter of Mutton, Thomas Murray, Brown's lane
Queen's Head, Honour Lister Studholme, Bridge steet
Railway Hotel, John Teasdale, London road
Red Lion, R. Boustead, 7, Botchergate
Rose & Castle, Joseph Boustead, 1, Finkle street
Rose & Crown, Jno. Norman, Lowthian lane
Royal Hotel & Posting House, T. Elsworth, 19, English street
Royal Oak, James Clarkson, 27, Bridge streets
Sailor, Robt. Taylor, Caldcts
Saddle, James Armstrong, Bridge lane
Saracen's Head, Christopher Bewley, 13, Annetwell steet
Scotch Arms, Sarah Tweddle, 30, Rickergate
Shakespeare Tavern, George Foster, 27, St. Cuthbt's lane
Ship, Mary Richardson., 2, Rickergate

Spread Eagle, Joseph Riley, 84, English street
Sportsman, Jane Beswick, 35, Bridge street
String of Horses, Eliz. Bell, 51, English street
Sun, George Gate, 2, Bridge street
Three Cannons, W. Graham, ct. 12, Scotch street
Three Crowns, Eliz. Davidson 36, English street
Three Crowns, John Beck, 12, Rickergate
Three Horse Shoes, Daniel Campbell, 148, Botchergate
Turf Hotel, Aaron Martin, The Swifts
Victoria Steamer, Isc. Bell, Irishgate brow.
Waggon and Horses, James Scott, 157, Botchergate
Waggon and Horses, Thomas Atkinson, Caldew bridge
Weavers' Arms, Thos. Jackson, Shaddongate
Wellington Inn, James Bell, 37, English street
Wheat Sheaf, William Bell, 24, Rickergate
White Hart, Isabella Nicholson, 18, English street
White Horse, Rt. Hallaway, 44, English street
White Lion, Jane Reed, 16, English street
White Swan, John Binney, 55, English street
William James, Wm. Rigg, Bridge lane
Wool Pack, Jos. Thompson,70, English street

Above: The Sportsman.

Left: View from The Sportsman over towards St Cuthbert's Church.

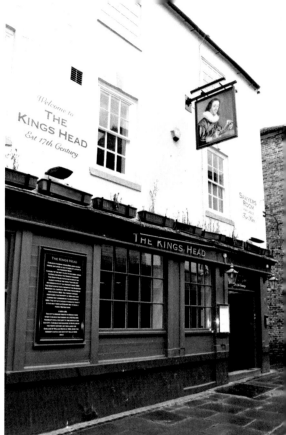

Above left: Crown & Mitre Hotel.

Above right: King's Head.

Above: Town Hall, now the Tourist Information Office.

Right: Bank, on Bank Street.

Tullie House

The Tullie House Museum and Art Gallery was established by the Carlisle Corporation in 1893 and houses a fantastic collection of art, human history and natural science exhibits. The museum tells the story of the whole of Cumbria and not just Carlisle, a story that grew so much that in 1990 the museum underwent a major expansion to include new galleries, a lecture theatre and a shop, as well as a restaurant.

Tullie House.

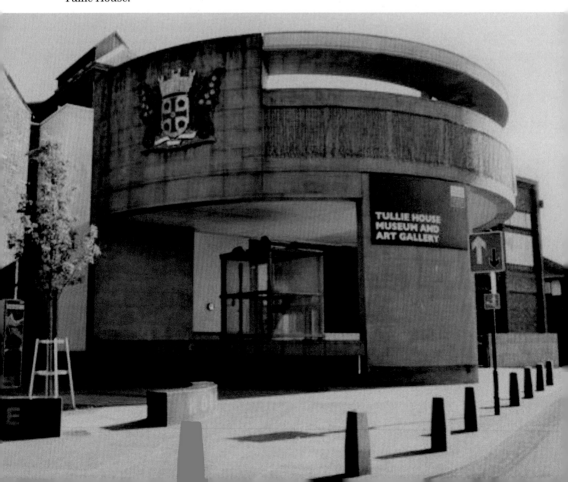

The name Tullie is taken from the family who used to live there until the nineteenth century, though the building can be traced back to the sixteenth century and for a time was known as the White House, when 'the house was modernised in the late 17th century under the ownership of Thomas Tullie, who was sometime Dean of Carlisle'. The house has a classical façade built in red and yellow sandstone, with ornate lead downspouts, bearing the date of 1689. On the ground floor there is a seventeenth-century fireplace and rising to the upper rooms is a beautiful Jacobean oak staircase.

The archaeology collection consists of over 12,000 man-made objects mainly from Cumbria and Carlisle, though some do come from much further afield. A hand axe is the oldest item and dates from 10,000 BC, but other eras are well represented too especially in the Roman collection. The connection to the Roman fort and Hadrian's Wall means the Tullie House Museum has one of the finest collections from this period.

The older items include Mesolithic and Neolithic pieces including axeheads and flint arrowheads, and the Bronze Age is represented by a spearhead mould and examples of gold jewellery. The early medieval covers the Anglo-Saxon and Viking settlement of the region with fragments from carved stone crosses and two Viking warrior burials that contain iron weapons and a small number of decorated items. The later medieval collection contains objects of wood and leather, as well as a large collection of pottery.

When I was visiting the museum, my experience was enhanced by the helpful staff, who helped explain the well-organised collections and the general high standard of the displays. The art space was also a visual treat, including space for local as well as other artists to display their high level of creative expertise.

Upperby Rail Yard and Depot

I usually steer well clear of including any rail history in my books, but without a significant reference for the letter U, I had to cover the Carlisle Upperby Traction Maintenance Depot (TMD). Upperby is a suburb to the south of Carlisle and the Traction Maintenance Depot was originally built to service steam locomotives. The old steam shed used to be known as 'the Lanky', a reference to when it was originally built by the Lancaster & Carlisle Railway, before the depot became part of the London, Midland & Scottish Railway (LMS) as part of the 1923 Grouping. The LMS decided to rebuild the depot in 1948 and replaced the original shed with a large concrete roundhouse.

In the 1960s, Upperby was allocated diesel locomotives but once the new purpose-built diesel depot, Kingmoor TMD, was completed, Upperby was closed as a locomotive depot on 1 January 1968. Unfortunately, the roundhouse was demolished in 1979, but the remaining buildings were used for carriage maintenance and servicing until the early 1990s.

Upperby is no longer an operational depot, although some sidings are still used to store redundant wagons and part of the land is used by Network Rail for office space and storage of equipment. The former carriage shed was demolished in December 2016.

Carlisle Station

The Carlisle Citadel Railway Station opened on 10 September 1847, for the Lancaster and Carlisle Railway and also served the Caledonian Railway, Maryport & Carlisle Railway and Newcastle & Carlisle Railway. Once the Midland Railway reached Carlisle with the Settle–Carlisle line in 1876, it was rebuilt and enlarged in 1878–80. It was served by seven different railway companies and, due to this complexity, by Act of Parliament in 1861, they established the Citadel Station Joint Committee to manage the station.

The architect who designed the London Stock Exchange, Sir William Tite, built it in a Tudor style and included decorated Gothic fireplaces, a charming clock tower and linen-fold wood-panelled doors. It had a 7-acre [2.8-hectare] glass roof with giant

Gothic wood screens at each end, but after they had been painted over in black as an air-raid precaution in the Second World War they suffered from neglect and were demolished in 1957. The building is among the most important early major railway stations in Britain.

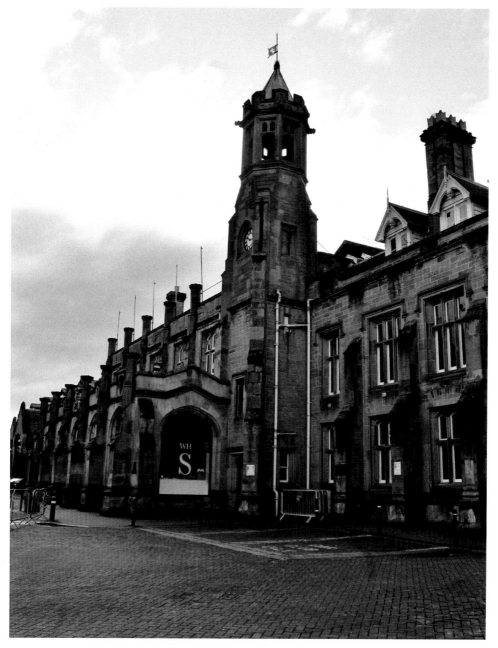

Carlisle station.

Vallum and Wall

A significant factor in the early development of the city of Carlisle is the location of Hadrian's Wall and the Vallum. The Vallum is an impressive earthwork to the south of the wall and is still clearly visible in large sections of the landscape with ditches and mounds running parallel to the wall.

The Vallum is made up of a ditch, around 6 metres wide and 3 metres deep, two mounds either side of the ditch around 2 metres high and set back from the ditch, and there is often a third mound on the southern edge of the ditch. There may have also been a road or pathway between it and the wall making the whole construction around 36 metres across. Typically, the Vallum follows very close to the south of the wall but where the land is rocky and hilly, the Vallum can be up to 700 metres from the wall. The system seems to have included crossing points in the vicinity of the main forts and some of the milecastles.

Though the purpose of the Vallum is unclear, the regular practice of a Roman army was to protect the front and the rear – after all they were an occupying force in a country that could rebel against oppression. It may have also marked a militarised zone to ensure only the authorised personnel and those tasked with the protection of the wall were allowed in this back area. Another possible reason is simply space to control trade across the border where goods could be checked and taxed if necessary.

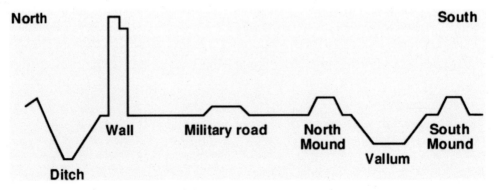

Simple section of the Vallum and Wall.

PRESIDENT WOODROW WILSON

Woodrow Wilson.

The Vallum runs right up to the River Eden in Carlisle, close to the Eden Bridge and cricket ground. It then exits and continues to Dykesfield on the Solway, before appearing again down the coast until at least Bowness-on-Solway.

The full function of this earthwork seems to have been relatively short-lived and within perhaps twenty to thirty years sections were filled in. It may have been built to protect the building of the wall and to prevent any outflanking of the wall during construction, but this is just conjecture.

W

Woodrow Wilson

Carlisle and Cumbria have several connections to the highest political office in the United States of America (see also the letter Z). Woodrow Wilson first visited the area as an unknown tourist in the 1890s, but on 29 December 1918, he made his famous 'pilgrimage of the heart' visit. His link to the city was through his mother,

Plaque on the City Church.

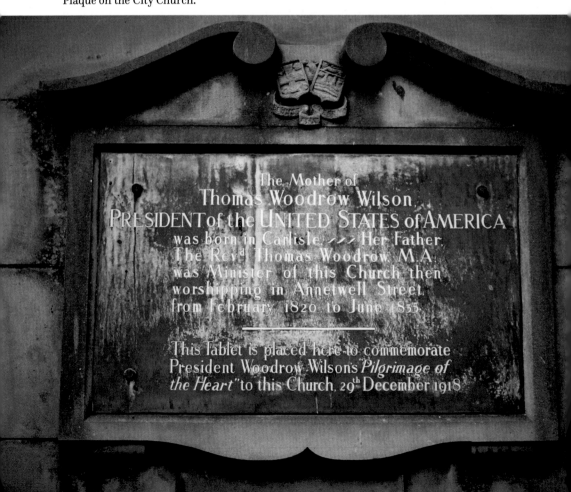

Janet Woodrow, who was born in Carlisle, the daughter of Revd Thomas Woodrow, a Scottish Presbyterian minister who preached at a church in Annetwell Street between 1820 and 1835. The family emigrated to New York in 1836.

Thomas Woodrow Wilson was a statesman, lawyer and academic who served as the twenty-eighth president of the United States from 1913 to 1921. During his stay in England between 26 December and 31 December, he met with Prime Minister Lloyd George and King George V, but on 29 December he came to Carlisle as part of his 'pilgrimage of the heart' to visit the area where his mother was born. He arrived by train at the Citadel Station (the royal train was made available for his use), where he was received by the mayor of Carlisle, Bertram Carr, and a gathering of dignitaries. He and the First Lady were escorted from here to the Crown and Mitre Hotel where he signed the freemen's roll. This roll is collected in what is known as the Dormont Book. He also visited Annetwell Street where he saw the site of his late grandfather's chapel and the house in Warwick Road where his mother grew up. Later in the day, the president made an address those gathered at the Lowther Street Congregational Church by the pastor Revd Edward Booth.

Followings the visit, *The New York Times* reported, 'The warmth of the greeting of the people in the town and of the thousands of strangers from the surrounding country more than offset the dreariness of the weather.'

His visit is commemorated by a plaque on the outside wall of the Carlisle City Church on Lowther Street, and when I visited the city there was a display being shown in the Tourist Information Office.

The Woodrow Wilson Society was founded in Carlisle in 1999 and has celebrated any notable anniversaries since that time, none more so than the 100th anniversary of his visit where there was a re-enactment, including actors who delivered part of his original address.

X – Market Cross

The Market Cross was built in 1682 but on the site of a previous medieval cross. This Grade I listed monument was restored in 2009 and is inscribed 'Joseph Reed Mayor 1682'. It features sundials at its head and is topped by a lion sitting holding a scroll with the city arms.

Below left: The Market Cross outside the old Town Hall, now Tourist Information Office.

Below right: The Market Cross.

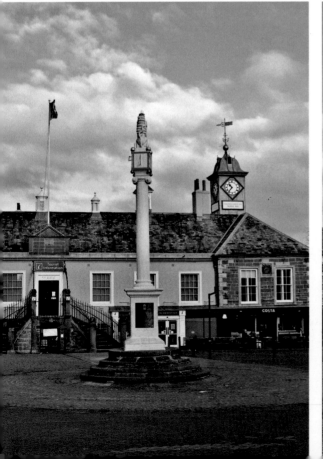

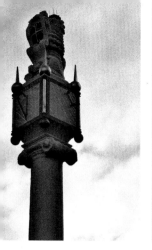

Above left: Close-up of the top of the Market Cross.

Above right: Market Hall.

The people of Carlisle may have had some rights to hold markets since 1158, but *c.* 1292, in the reign of Edward I, the citizens pleaded that they were entitled to murage (a levy to maintain the city walls) for all goods exposed to sale in the town, a free guild, a market and fair. They claimed the free guild under a Richard I charter, but could not prove their claims because the records of the town had been destroyed by fire.

'The whole city appears to have been consumed, with the priory, the convent of Grey Friers, and their churches; the convent of Black Friers, being near the eastern wall, alone escaped. This dreadful conflagration is said to have been occasioned by an incendiary, who, from motives of resentment, set fire to his father's house, and was executed for the fact.'

Edward agreed to restore these rights to the city because of the charters that had been consumed by the flames.

In 1352, King Edward III, because of the importance of Carlisle as a frontier town, the recent ravages of the plague, and the assaults of besieging armies, granted further confirmation of all the privileges they had previously enjoyed. Markets were held on Wednesdays and Saturdays and a fair for sixteen days was to commence on the assumption of the Virgin Mary or 15 August. They could also appoint a mayor, bailiffs and coroners. King Charles I, in 1637, confirmed all the former charters and incorporated the citizens. The corporation consists of twelve aldermen, one of whom is annually elected mayor, two bailiffs or sheriffs, two coroners, and twenty-four common-councilmen, with power to elect a recorder and town clerk. The city used to send two members to parliament since the reign of Edward I, but this was reduced to one representative in 1885.

Market Hall

The site of the Market Hall had been in use since 1799 as a butchers' market and was extended in 1854 to accommodate a butter and egg market (fish stalls were incorporated into the butchers' shambles). The current hall was built between 1887

and 1889 for Carlisle Corporation by Arthur Cawston and Joseph Graham, both of Westminster, with ironwork manufactured by Cowans, Sheldon & Co. Though the floor space for the market has been reduced and other main retailers are housed in the space, the former grandeur of the building can still be seen.

Above: Market Hall ironwork.

Left: Market Hall stalls.

Y

Yellow Earl, 5th Earl of Lonsdale

One of the oldest and most influential families in the country is the Lowthers, who can trace their origins back to a Viking settler called Dolfin. The Lowthers have been knights and earls, Members of Parliament, industrialists, agriculturalists, soldiers and adventurers. They have been involved in most of the significant events of Westmorland and Cumberland, from escorting Mary, Queen of Scots to Carlisle, to resisting Jacobites, from being Members of Parliament, to Lord Lieutenants of Cumberland and Westmorland. They can claim to have figures such as Pitt the Younger and Wordsworth as protégés, and Kaiser Wilhelm II was a friend and visited Lowther Castle before the First World War. Their coal and iron business was so huge it expanded fishing villages into large ports at Whitehaven and Maryport, and most local towns have a street named after them, Carlisle being no exception. One of their most notorious earls was Hugh, the 5th Earl of Lonsdale, also known as the 'Yellow Earl', who as a younger son was not expected to inherit the family estates.

When his brother, George Henry, the 4th Earl, died young in 1882, it was Hugh who became the 5th Earl of Lonsdale. He was described as 'wayward' after leaving Eton School but seems to have had an almost insatiable spirit of adventure – he had joined a travelling circus for year, and went to America to hunt buffalo. He had pawned his

Lowther Castle near Penrith.

future birthright to make his fortune from cattle but after the scheme failed, it was the family trustees who bought back his rights so he could live at Lowther. He had scandalous affairs with the actresses Lillie Langtry and Violet Cameron and is said to have been advised by Queen Victoria to leave the country to let the scandal die down. So being the adventurer, he headed to the Arctic, on a punishing polar expedition in which over 100 guides died, but when he returned in 1890 became a hero and a celebrity.

He was known as the Yellow Earl when he decided the colour of the local Conservative Party would be this colour and he maintained yellow-liveried servants and a fleet of yellow motor cars including Rolls-Royces and Bentleys. He had a pack of yellow dogs and would have the gardeners grow yellow gardenias for his buttonhole. He extended the estate by flattening twenty farms to 'improve' the park for entertainment and royal visits. The future enemy and grandson of Queen Victoria, Kaiser Wilhelm II, would also be a guest of the earl in 1895. He was a talented horseman, a patron of hunting and racing, and founder of the royal International Horse Show. He was a supporter of local sports such as hound-trailing, fell-running and Cumberland and Westmorland wrestling, but most of all is known for the instigation of the world-famous Lonsdale Belt intended to be awarded to British boxing champions.

The earl was busy spending the family fortune and following the First World War, like many other estates, fell on hard times. The combination of high taxes and the Great Depression of the 1930s led to the closure of the castle in 1936. The Yellow Earl died in 1944 with no heir, so the estate and his debts were inherited by his youngest brother, Lancelot. The new 6th Earl had little choice and sold most of the family collections in 1947.

Part of the estate and castle are open to the public, and the grounds undergoing refurbishment make a day out here an exhilarating walk through history.

Tower Street.

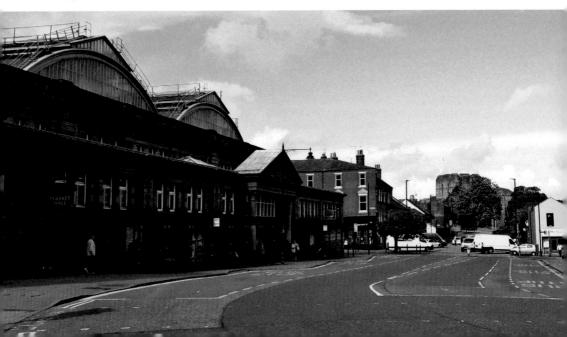

Z

Zachary Taylor

Zachary Taylor was the twelfth president of the United States. He was born on 24 September 1784 in Orange County, Virginia, and is yet another Carlisle connection to the highest office in the United States of America. He was descended from James Taylor, who came from Carlisle in 1658 and served as president from March 1849 until his death in July 1850.

His father was Colonel Richard Taylor, who was an officer in the war of the Revolution, known for passion and daring. After the war he retired to private life, and in 1785 made his home near to the present city of Louisville, where he later died. Zachary was the third son.

Postcard of Zachary Taylor.

In 1808, Congress authorised the raising of additional forces and at the same time tensions were rising again between the United States and Great Britain. Zachary Taylor, aged twenty-four, applied for a commission, and was appointed a 1st lieutenant in the 7th infantry, and by 1810 was promoted to captain. In the same year he married Miss Margaret Smith and she accompanied him to the frontier where he was involved in troubles with the Indian tribes.

In June 1812, war was declared against Britain and, supported by the British, there was fears of an Indian invasion. Captain Taylor was ordered to Fort Harrison with his company of infantry to prepare to defend the place. He defended the fort with skill and managed to successfully repel a large force of Indians. For this action he was promoted to major, and continued to serve in the Indian war. He was involved in various battles with the Indians and British allies before the cessation of hostilities.

After the war, the United States forces were greatly reduced and Major Taylor was reduced to the rank of captain. He 'felt the injustice, but resigned from the army without complaint' and returned home to farm. Later he was restored to the rank of major, and returned to the army, where he served with distinction on the frontier in the Indian wars and was elevated to the rank of brigadier-general.

Texas was annexed to the United States in 1845, and Mexico threatened to invade and recover the territory. General Taylor was ordered to defend it and proceeded with his force to a fort on the Rio Grande, which was considered the boundary of Texas. Taylor defeated the Mexican army in two engagements after they crossed the Rio Grande. He then advanced into Mexico and forced the surrender of Monterey and agreed an armistice – though the land he took was eventually recovered by a force under General Santa Anna.

Not only was Taylor a military man but he was a seeker of knowledge and he had studied both ancient and modern history. He was considered a learned man who would study people, both friend and foe, before any campaign, and would seek to understand the position and design of any enemy. In battle he was considered vigilant, calm and considerate, but could be stern and inflexible.

Before his nomination for the presidency it seemed he had little in the way of political aspirations and was looking forward to retirement from the army to return to farming. Unfortunately, he only lasted sixteen months in office and did not live long enough to stamp his character on his administration. He is buried in the family cemetery, 5 miles from Louisville.

Zachary Taylor was also related to the fourth president, James Madison.

Additional Photographs from around the Cathedral Complex and St Cuthbert's Church

The abbey complex is a gated area off Castle Street and contains the Fratry, the Reqister Office, the Deanery, and the Prebendaries' houses.

Right: 1820 map of the cathedral complex.

Below: The cathedral complex from the West Walls.

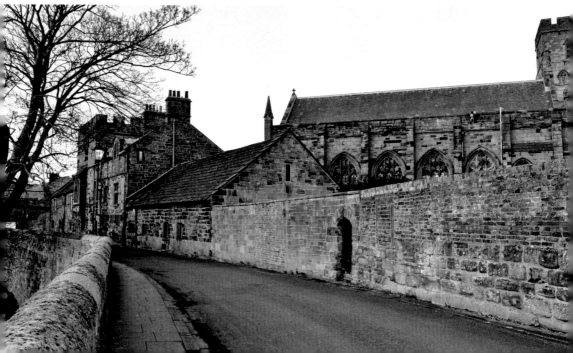

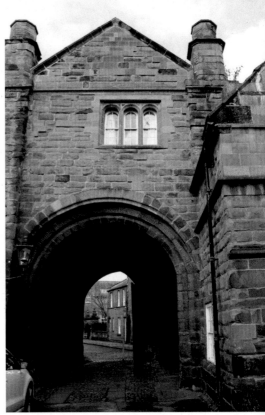

Above left: Buildings within the cathedral complex.

Above right: Entrance gate.

Left: St Cuthbert's Church.

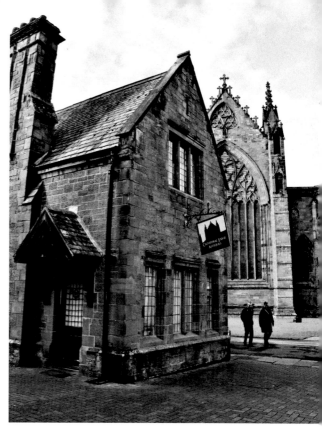

Above left: Stained-glass window in St Cuthbert's Church.

Above right: Entrance to the cathedral complex.

Below: Inside St Cuthbert's Church.

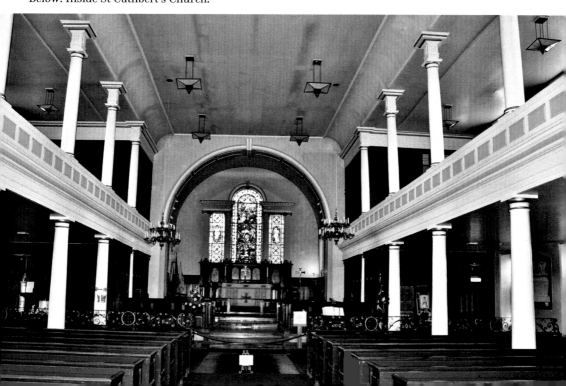

Carlisle Timeline and Significant Events

AD 78: The Romans build a fort and a civilian settlement (vicus) develops outside the walls.

399: Roman soldiers leave Hadrian's Wall and they soon abandon Carlisle.

685: St Cuthbert builds a monastery at Carlisle.

876: The Danes sack Carlisle.

945: The Anglo-Saxons recapture Carlisle.

1092: William Rufus rebuilds Carlisle Castle after dispute with the Scots.

1122: A priory is built in Carlisle.

1130: The earliest date stone walls are built around Carlisle.

1133: Carlisle is made the seat of a bishop.

1135: The Scots capture Carlisle, remaining until 1154.

1158: Carlisle is given a charter.

1223: The friars arrive in Carlisle.

1292: Carlisle is badly damaged by a fire.

1315: The Scots again besiege Carlisle but they are unable to capture it.

1349: The Black Death overcomes the city.

1541: Henry VIII closes the priory and the two monasteries.

1597: Plague strikes the whole of Cumberland and Westmorland.

1600: The population of Carlisle is estimated at 2,500.

1644: The Roundheads lay siege to Carlisle.

1645: The Roundheads capture Carlisle.

1682: Carlisle Cross is erected on the site of the old Market Cross.

1689: Tullie House is built.

1745: The Jacobites capture Carlisle but surrender within two months.

1750: Carlisle has a population of around 4,000.

1758: A turnpike road is built to Newcastle.

1778: St Cuthbert's Church is built.

1787: The first bank in Carlisle opens.

1798: Carlisle gains its first newspaper.

1801: The population of Carlisle is 9,555.

1804: The streets of Carlisle are lit by oil lamps.

1813: Carlisle gains its first theatre.

1819: The streets of Carlisle are lit by gas.

1832: Cholera strikes Carlisle.

1838: A railway connects Carlisle to Newcastle.

1841: Carlisle gains an infirmary.

1848: Cholera strikes again, which instigates a piped fresh water supply.

1851: The population of Carlisle is over 25,000.

1885: The first telephone exchange in Carlisle opens.

1889: The covered market is built.

1899: Carlisle gains an electricity supply.

1900: Electric trams begin running in Carlisle.

1901: The population of Carlisle is 45,000.

1912: The first boundaries of Carlisle are extended to include Stanwix and Botcherby.

1964: Carlisle Civic Offices are built.

1973: Radio Cumbria begins broadcasting.

1974: A ring road is built around Carlisle.

1986: A new library opens.

1989: Carlisle city centre is pedestrianized.

2005: Carlisle suffers severe floods.

2011: The population of Carlisle rises to 107,524.

Bibliography

Mitchell, W. R., *The Eden Valley and the North Pennines*, 2007
Towill, Sydney, *Carlisle (History of)* 1991
Webb, Tina, *Verbal Histories of Cumbria* (unpublished)

Cumberland & Westmorland Herald

Roman-britain.co.uk
www.cumberlandscarrow.com
www.cumbriacountyhistory.org.uk/township/carlisle
www.forces-war-records.co.uk
www.gatehouse-gazetteer.info
www. Hadrianswallcountry.co.uk
www.localhistories.org

Carlisle Tourist Information

Acknowledgements

Thanks to my family, the publishers and the good people of Carlisle who made every visit to the city a pleasure. A special thanks to Sarah at the Tourist Information Centre for her help and guidance, and the staff at the Tullie House Museum.

About the Author

Born in Barnard Castle and currently residing in York, Andrew is a history enthusiast who has been written several books for Amberley Publishing and has contributed to TV series filmed in the north of England. His other books include *Secret Richmond & Swaledale, Secret Barnard Castle & Teesdale, Secret Kendal* and *Secret Penrith*. Recently published is the *A–Z of the City of Durham: Places, People, History* and *Historic England: Yorkshire*. His Facebook page is 'Andrew Graham Stables' and is regularly updated with news about his latest projects.